*photographing*
the Great
Smoky
Mountains

Where to Find Perfect Shots and How to Take Them

Jim Hargan

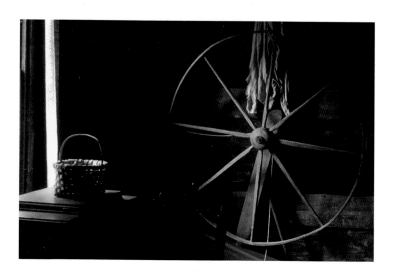

THE COUNTRYMAN PRESS
WOODSTOCK, VERMONT

Maps by Paul Woodward, © The Countryman Press
Book design and composition by S. E. Livingston

Photographing the Great Smoky Mountains
978-0-88150-855-0

Published by The Countryman Press,
P.O. Box 748, Woodstock, VT 05091

Distributed by W. W. Norton & Company, Inc.,
500 Fifth Avenue, New York, NY 10110

Printed in the United States by Versa Press. East Peoria, IL

10  9  8  7  6  5  4  3  2  1

*Title Page: Spinning wheel in the log farmhouse
at the Mountain Farm Museum
Right: Snow at Newfound Gap*

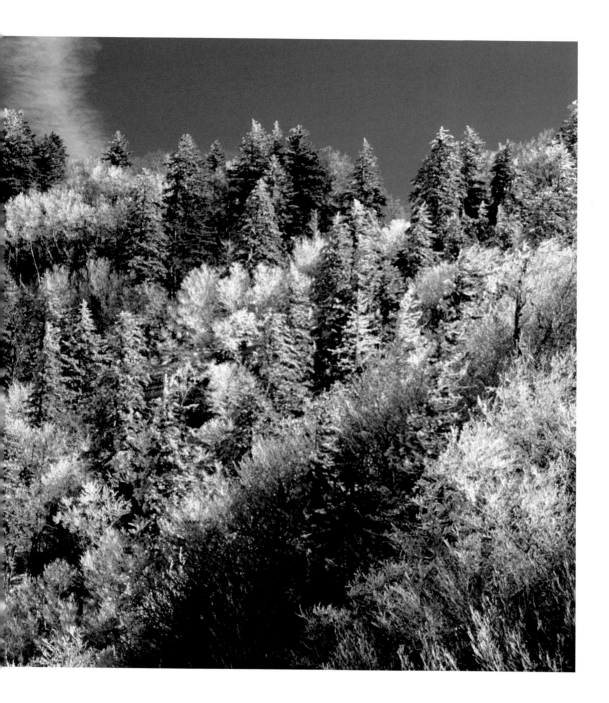

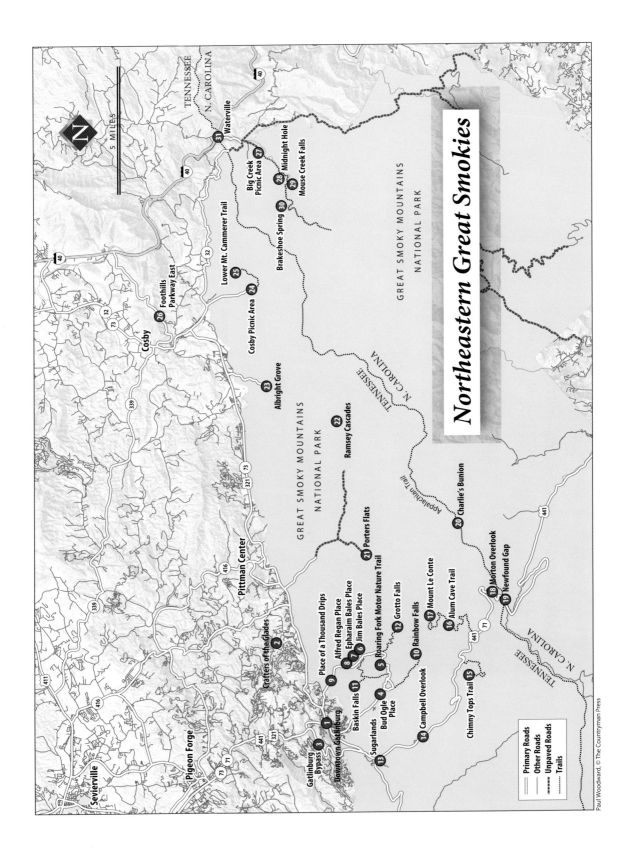

# Northeastern Great Smokies

N

5 MILES

Sevierville

Pigeon Forge

Gatlinburg Bypass

Downtown Gatlinburg

Pittman Center

Cosby

Waterville

TENNESSEE
N. CAROLINA

GREAT SMOKY MOUNTAINS
NATIONAL PARK

GREAT SMOKY MOUNTAINS
NATIONAL PARK

TENNESSEE
N. CAROLINA

TENNESSEE
N. CAROLINA

Appalachian Trail

1 Sugarlands
2 Craffers of the Glades
3 Sugarlands
4 Bud Ogle Place
5 Roaring Fork Motor Nature Trail
6 Jim Bales Place
7 Ephraim Bales Place
8 Alfred Regan Place
9 Place of a Thousand Drips
10 Rainbow Falls
11 Baskin Falls
12 Grotto Falls
13 Sugarlands
14 Campbell Overlook
15 Chimny Tops Trail
16 Alum Cave Trail
17 Mount Le Conte
18 Morton Overlook
19 Newfound Gap
20 Charlie's Bunion
21 Porters Flats
22 Ramsey Cascades
23 Albright Grove
24 Cosby Picnic Area
25 Lower Mt. Cammerer Trail
26 Foothills Parkway East
27 Big Creek Picnic Area
28 Brakeshoe Spring
29 Mouse Creek Falls
30 Brakeshoe Spring
31 Waterville

Midnight Hole

Primary Roads
Other Roads
Unpaved Roads
Trails

Paul Woodward, © The Countryman Press

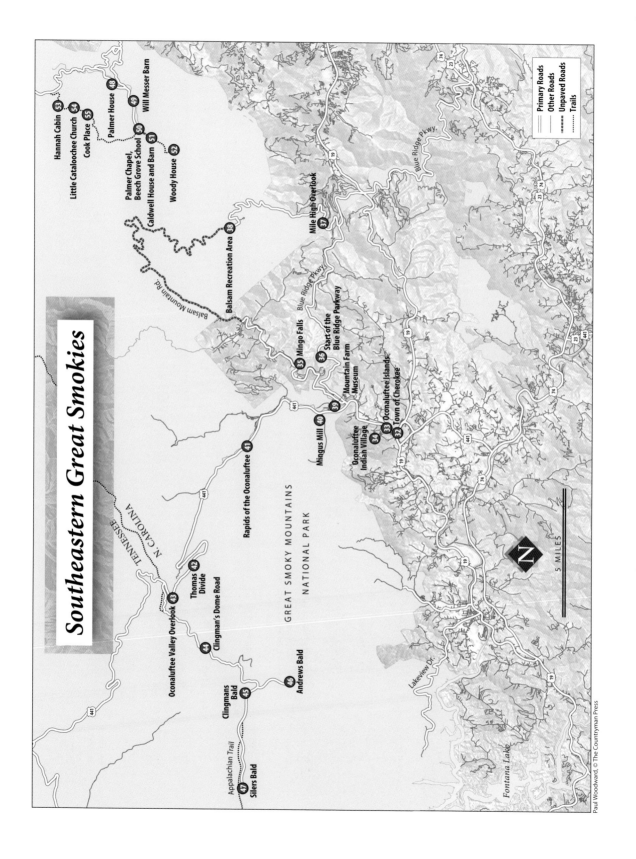

# Southeastern Great Smokies

Hannah Cabin 53
Little Cataloochee Church 54
Cook Place 55
Palmer House 48
Will Messer Barn 49
Palmer Chapel, Beech Grove School 50
Caldwell House and Barn 51
Woody House 52

Balsam Mountain Rd.

Balsam Recreation Area 38

Mile High Overlook 37

Blue Ridge Pkwy.

Mingo Falls 35
Start of the Blue Ridge Parkway 36
Mountain Farm Museum 39
Mingus Mill 40
Oconaluftee Islands 33
Town of Cherokee 32
Oconaluftee Indian Village 34

Rapids of the Oconaluftee 41

GREAT SMOKY MOUNTAINS NATIONAL PARK

TENNESSEE
N. CAROLINA

Thomas Divide 42
Oconaluftee Valley Overlook 43
Clingman's Dome Road 44

Andrews Bald 46

Clingmans Bald 45

Appalachian Trail

Silers Bald 47

Fontana Lake

Lakeview Dr.

Blue Ridge Pkwy.

**Primary Roads**
**Other Roads**
**Unpaved Roads**
**Trails**

N

5 MILES

Paul Woodward, © The Countryman Press

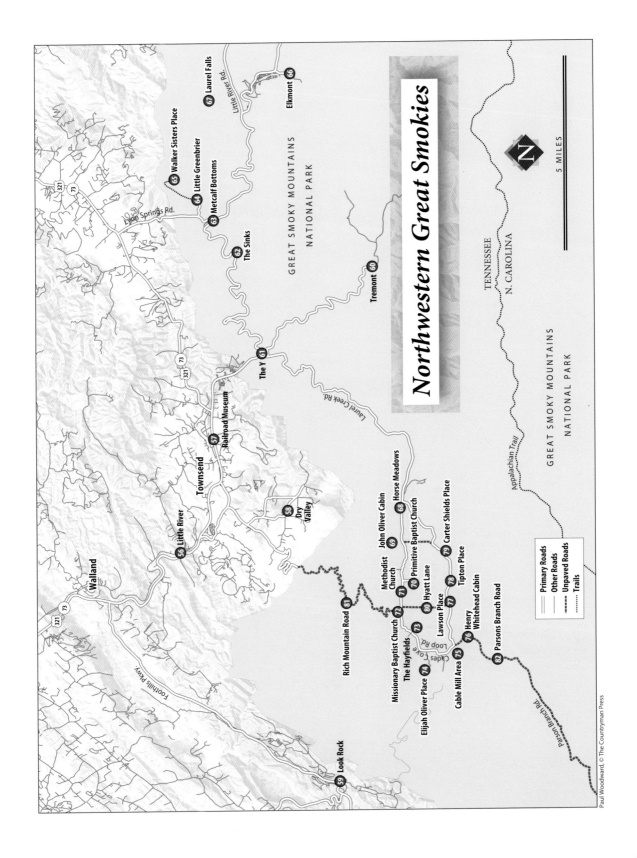

# Northwestern Great Smokies

GREAT SMOKY MOUNTAINS NATIONAL PARK

TENNESSEE
N. CAROLINA

GREAT SMOKY MOUNTAINS NATIONAL PARK

5 MILES

N

Primary Roads
Other Roads
Unpaved Roads
Trails

Walland

Townsend

56 Little River
57 Railroad Museum
58 Dry Valley
59 Look Rock
60 Tremont
61 The Y
62 The Sinks
63 Metcalf Bottoms
64 Little Greenbrier
65 Walker Sisters Place
66 Elkmont
67 Laurel Falls
68 Horse Meadows
69 John Oliver Cabin
70 Primitive Baptist Church
71 Methodist Church
72 Missionary Baptist Church
73 The Hayfields
74 Elijah Oliver Place
75 Cable Mill Area
76 Henry Whitehead Cabin
77 Lawson Place
78 Tipton Place
79 Carter Shields Place
80 Hyatt Lane
81 Rich Mountain Road
82 Parsons Branch Road

Loop Springs Rd.
Little River Rd.
Laurel Creek Rd.
Appalachian Trail
Foothills Pkwy
Cades Cove Loop Rd.
Parsons Branch Rd.

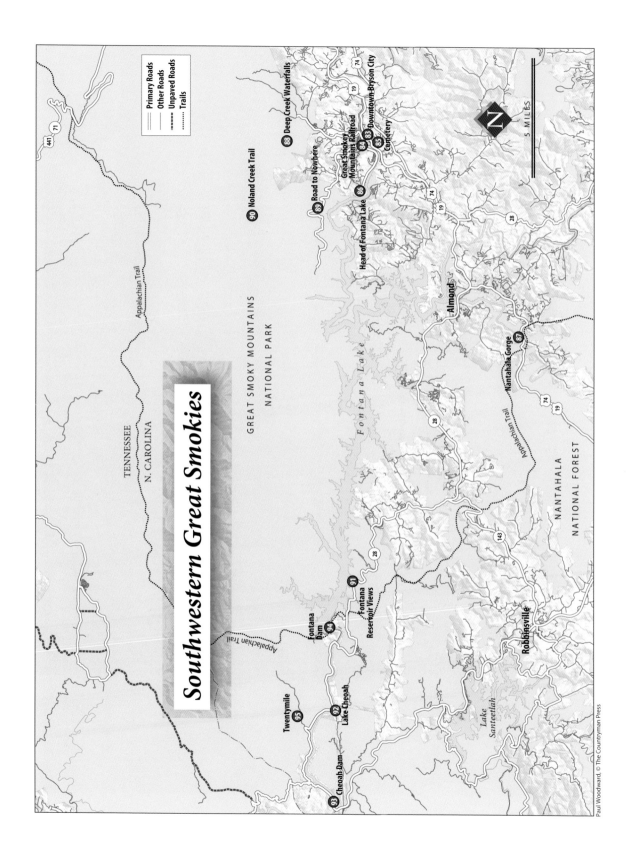

# Southwestern Great Smokies

Primary Roads
Other Roads
Unpaved Roads
Trails

N
5 MILES

TENNESSEE
N. CAROLINA

Appalachian Trail

GREAT SMOKY MOUNTAINS
NATIONAL PARK

Fontana Lake

88 Deep Creek Waterfalls
84 Great Smokey Mountain Railroad
83 Downtown-Bryson City
85 Cemetery
86 Road to Nowhere
89
90 Noland Creek Trail
87 Nantahala Gorge

Almond

Appalachian Trail

NANTAHALA
NATIONAL FOREST

Head of Fontana Lake

91 Fontana Reservoir Views
94 Fontana Dam
95 Twentymile
92 Lake Cheoah
93 Cheoah Dam

Lake Santeetlah

Robbinsville

Paul Woodward, © The Countryman Press

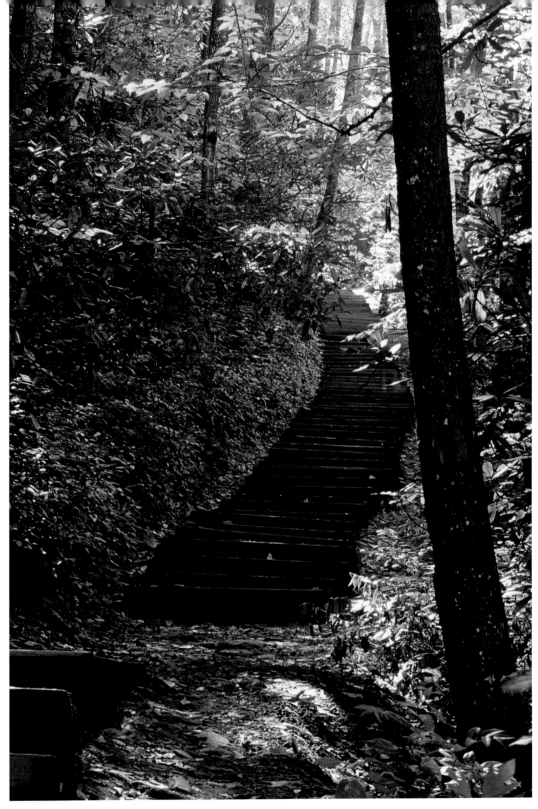

*Steps leading to Mingo Falls*

# Contents

*Flame azalea in the Balsam Recreation Area*

# Introduction

Somewhere between eight and ten million people will visit the Great Smoky Mountains National Park this year—as they have every year since 1975, making it the perennial winner in the contest to be the most visited national park in America. And no wonder. This park, straddling the state line between Tennessee and North Carolina, protects some of the grandest mountains in the Appalachians, with slopes that can climb a mile above the valleys below to reach peaks exceeding 6,000 feet in elevation. Indeed, this park contains 100 miles of ridgelines that never sink below 4,000 feet. In all, it contains over a half million acres of nonstop ruggedness, making it the second largest national park in the East.

This book will lead you to the most beautiful spots in and around the Great Smoky Mountains National Park, tell you what makes them so rewarding, and give you hints on how to capture that beauty in your photographs. You don't have to be a serious photographer—or even a photographer at all—to enjoy this book. You only need to be a lover of nature, and a person who appreciates the interesting, the unusual, and the spectacular. But if you're serious about your photography, you'll get a bonus: You'll be able to go straight to the best places, with help on weather and times of day as well as subjects calling out to be photographed. Nor will this book ignore the settled areas that surround the park. You'll be guided to the best photo sites around the tourist towns of Gatlinburg, Tennessee, and Cherokee, North Carolina; led across Fontana Dam (the tallest dam in the East); and directed through the streets of the homey county seat of Bryson City, North Carolina. You'll find the best overlooks, outside the park as well as in.

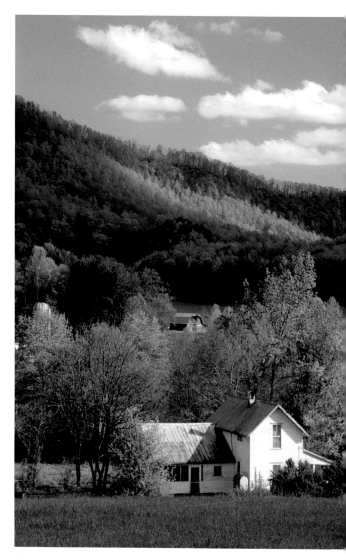

*Countryside near Cherokee*

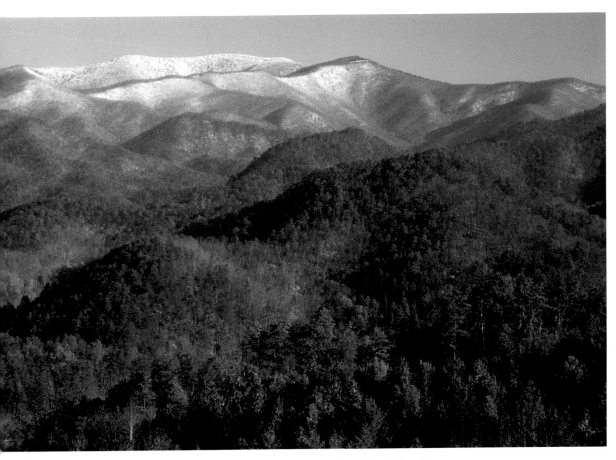

*The Smokies, viewed from a back road near Bryson City, North Carolina*

# Using This Guide

This book deals with the Great Smoky Mountains, both the range and the national park. For brevity, in this book the Great Smoky Mountains National Park will become simply "the national park," and the Great Smoky Mountains will be known as "the Smokies," their most common local name.

The mountain range called "the Smokies" is itself only part of a much larger district, a segment of the western edge of a vast mountainous oval occupying the western quarter of North Carolina and overlapping into Tennessee (as well as three other neighboring states). Too large to have its own name, this mountain district has instead a mishmash of localized ridgelines: the Smokies, the Balsams, the Nantahalas, the Cowees, the Blacks, the Unicois, the Unakas, Pisgah Ridge, Roan Mountain, Stone Mountain, and (of course) the Blue Ridge. We will call this giant, multi-state orogeny "the Blue Ridge District," following the lead of geologists. It's an island of extremely

old, super-hardened rocks projecting far above the surrounding valleys and hills, thrust upward as a block when Europe and America last collided and since then shaped by erosion. (Its enormous outwash formed Florida and much of the Southern coast.) This district is far taller than any other Eastern mountain area, with 40 peaks that top 6,000 feet (compared to only one such peak in New Hampshire, and none elsewhere in the East). The Smokies stand out in this tall and broken land by being even taller and more broken than most of it; fully half of the 40 super-high peaks are inside the national park's boundaries.

Within the national park, the Smokies stretch as an unbroken wall through the center, almost entirely above 4,000 feet, with numerous mile-high peaks. The border between North Carolina and Tennessee follows this ridgeline, as does (for the most part) the Appalachian Trail, the great long-distance footpath that wanders more than 2,000 miles from Georgia to Maine. Walk along this trail and you'll witness the defining sight of the Smokies: On the North Carolina side, the high crests of the Blue Ridge District stretch eastward beyond the horizon as a mad jumble of tall peaks and deep valleys, while on the Tennessee side the mountains end precipitously as a solid front, and plunge suddenly to the floor of Tennessee's Great Valley.

This high central ridge is pierced by exactly one road: the Newfound Gap Road. Formerly known as US 441, this National Park Service scenic highway bisects the park, crossing the Smokies at an elevation of 5,046 feet as it travels between Cherokee, North Carolina, and Gatlinburg, Tennessee. Access to the park is via either this great central highway, or any number of short and long roads that penetrate its perimeter. Because none of these roads is particularly good, it will take you a very long time to get from one section of the perimeter to the other. For that reason, this book divides the park into quadrants defined by the Newfound Gap Road and the crest of the Smokies. Each quadrant contains an area that can be readily explored from a base of operation immediately outside the national park: Gatlinburg, Cherokee, Bryson City, or Townsend.

Within each quadrant you'll find a number of entries, cross-referenced on the maps by number. These are grouped together into sections, or areas, in such a way that you could, if you wanted, visit every place in an area easily from a central location. Some entries describe a single feature; others describe a group of nearby related features. In both cases, each separate feature gets its own number. Anything of high visual interest, inside the park or adjacent to it, can become an entry—not just the forests, rivers, log cabins, and views for which the national park is justly famous, but also anything striking in the towns and farmlands along its borders.

Finally, a word about the vast areas not easily reached from a trailhead. Most of the park is backcountry, accessible only by multiday hikes along trails that commonly climb 2,000 feet in 2 miles. You might well want to try such an experience, testing yourself against the rugged mountains and enjoying the remoteness and solitude, but you need not do it to get the best photography; the wondrous beauties of the backcountry are echoed in less difficult locales. While this book actively seeks out-of-the-way places, for the most part it confines its search within three miles of a parking area. Only a few places (such as Mount Le Conte and Charlies Bunion) are so unique and spectacular that no easier substitute exists. In those cases, the entry will give complete descriptions of the time and effort you can expect and the problems you might encounter. All other locations are easily reached by car or a short hike.

*The sun sets through a summer haze in Cades Cove*

# How I Photograph the Smokies

Think of photography as storytelling. Before you set up your tripod, ask yourself, "What story do I want to tell?" Do not let your feelings of inspiration run away with you, and lead you to start clicking like mad in all directions. A certain deliberateness at this point will improve your results tremendously. What idea do you want to communicate? If it's "Boy, is this beautiful!" then ask: What's beautiful about it? Isolate the feature, and only then tell the story.

Just as a written story has a beginning, a middle, and an end, a photographic story has a foreground, a middle ground, and a background. Place your main feature within the camera's rectangular frame, then organize a foreground and background to tell the story. Place wildflowers in the foreground of the vista to tell the story of a lovely, grassy area; place a tree trunk in the foreground of a waterfall to tell the story of a wooded view. Once you've chosen the elements of your story, experiment; film is cheap, and digital film is free. Make your final decision once you're home.

One good way of gaining this deliberateness, this conscious storytelling, is with a tripod. We think of a tripod as a way of increasing resolution by suppressing camera motion, but it's more than that. By locking down the camera on a single, firm spot, you can contemplate the elements of the image at your leisure, think about the composition of your story, make fine adjustments. Freed from the tyranny of the shaking hand, you can stop your lens down as far as it goes, then adjust your back-to-front focus ("depth of field") exactly the way you want. You might then try screwing a polarizing filter over your lens, quadrupling the time your shutter is open but intensifying your colors. Instead of blasting away at different exposures

("bracketing"), you might try carefully reading the light reflected off different elements of your story (look up "spot metering" in your camera manual), delicately balancing the tones to get the story just right. When you are telling photographic stories about the Smokies, certain themes suggest themselves. I'll be returning to these themes again and again in the listings for specific locations—suggestions of the types of stories a location might tell. At this point, however, I will briefly describe each of the themes I've personally enjoyed exploring in the Smokies.

The story of mountain grandeur may well be the one you wish to explore in the most depth. This tale, however, will be different from the one you would tell, for instance, about the Rocky Mountains. The Smokies are comparable to the mountains of the West in steepness and ruggedness, if not height—but they don't look it. Their continuous tree cover gives them a softer, more graceful appearance. You will want to explore the story of grandeur within the context of this great forest, one of the richest and most varied in the world.

A second mountain theme is more local. The Smokies are not just mountains; they are the front of the mountains. On the North Carolina side, mountain ranges as rugged as the Smokies—the Balsams, the Nantahalas, the Cowees, the Unicois—stretch away to the horizon as an unorganized jumble of high peaks, steep slopes, and V-shaped valleys. On the Tennessee side, the mountains end, plunging into a flat valley that stretches out of sight to the west. (Actually, once you're on the floor of this valley you'll find all sorts of mountainous-looking local relief, but none of it is tall enough to look impressive from the mile-high Smokies

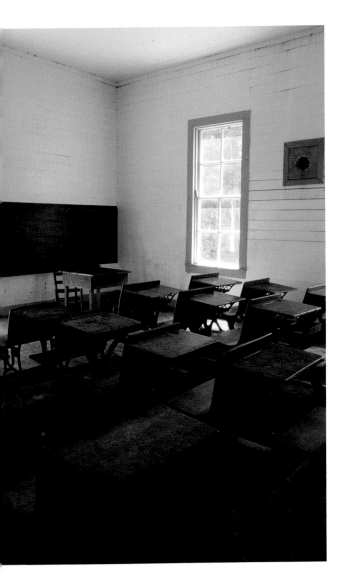

*One-room schoolhouse at Cataloochee Cove*

This is one of the most varied forests in the world, with more tree species than all of temperate Europe. In the unique environment known as the cove hardwood forest, you can find 30 or more tree species in a single acre.

Related to the richness of the forest is the abundance of water. Rainwater sinks quickly through the soil into the cracks in the bedrock—and then runs out again as springs. These quickly consolidate into quiet streams, and these merge to form rivers. Within a linear mile or two of the crest, these rivers become violent and filled with rapids, the results of a hundred inches of rain a year. An occasional extra-hard ledge will form a waterfall, anywhere from 9 to 90 feet tall.

While many photographers are content to tell the story of nature in the Smokies, others among us are not satisfied until we weave within it the story of man. The park itself presents us with two starkly different themes. The first is pioneer history, preserved by the park service in a series of log cabins, farmsteads, and fields, and intentionally presented as a story of people in harmony with their surroundings. Do you accept this story? Or do you push to find another, less romantic, one? The second human story is that of logging, the stripping of nearly all the forests from the Smokies during the 1920s in a mad dash to beat the government's painfully slow condemnation for parklands. Logging sites and logging railroads date from this era, as do mammoth remains of environmental destruction. As with all of these story themes, you'll find specific sites in the listings.

Outside the park are two more themes on the human story: the vulgar carnival of mass market tourism and the quieter, less evident portrait of mountain people going about their lives. One final human theme deserves attention: outdoor recreation. This may well be the reason you're here in the first place, so be sure to capture it in your photographs. Your family

crest.) You will want to capture both sides of the Smokies.

The next story that suggests itself is that of the forest. The trees are huge and beautiful; the understory is colorful with the blossoms of dogwood, azalea, silverbell, rhododendron, and mountain laurel; and the forest floor is varied with moss, lichens, and rocks. Look a bit deeper and you will find another forest story:

picnicking, your children splashing in a mountain stream—these may well be the most important stories you'll tell.

## Equipment and Technique for the Smokies

I've already discussed how significantly a tripod can improve nearly every shot, not just by improving resolution (and honestly, how many of your pictures are too sharp?), but also by improving your artistic control. I carry two tripods in my vehicle at all times: a lightweight Gitzo, and a Manfrotto that weighs 15 pounds and extends to six feet. Each cost me about $300, and each is over 10 years old. The Manfrotto is particularly good in the Smokies, as I can set up on near-cliffs by simply extending one leg downhill. The Gitzo, on the other hand, is superb when I have to walk any distance. Whatever you choose, you'll want to spend a bit extra to make sure it's sturdy, can be adjusted with simple tools, and offers replacement parts.

In order to get top-notch pictures you don't necessarily need a pro-level camera—but it helps. I personally cannot imagine using a camera that doesn't allow me to change lenses. Nor do I use zoom lenses; a zoom is always a compromise between flexibility and quality. However, these are only preferences, an approach that has worked well for me for decades. Other excellent photographers use other approaches. If you wish to publish your pictures in top magazines, you'll either need at least 12 megapixels of resolving power, or transparency (slide) film.

Lenses are another area of personal preference. I carry a number of fixed focal length lenses rather than zooms; this is less bothersome than it sounds, as it's easy to change lenses on a tripod-mounted camera. Here is my typical bag, with all lenses given for 35mm full frame: 21mm (which yields an almost 90-degree field of view), 28mm, 50mm, 90mm, 135mm, and 200mm.

Commercially saleable wildlife photography is highly specialized, with its own body of knowledge. It also requires expensive equipment and very long periods of time. The problem with trying to capture the moment with normal pro equipment is that it takes too long to set up the tripod and the telephoto lens; specialists either spend a long time hidden in a carefully camouflaged blind, or cheat by going to a zoo or wildlife ranch. The solution is to stay in your car, roll down your window, place a bean bag on the sill, and rest your camera with a 200mm lens on the sill. Large animals in the Smokies are used to cars, and generally won't spook until someone tries to open a door and get out. It's a good idea to keep a spare camera body fitted with a 200mm lens beside you while you drive. Try early morning or dusk in Cades Cove or Cataloochee Cove; the latter is good for elk as well as deer and bear.

I used to carry a whole raft full of different filters, but now I'm down to one—a polarizer, the only filter that cannot be faked in Photoshop. When the sun is over your shoulder its light will bounce randomly off shiny objects, including the sky (which is full of shiny water vapor). This gives everything an ugly bluish cast. A polarizing filter removes the scattered light, allowing only the directly reflected light (about 25 percent of the total light) to enter your camera. It eliminates the bluish cast and replaces it with vibrant, saturated colors. It is imperative to use it under overcast skies; even though you will have a hard time seeing the difference in your viewfinder, the final results will be very dramatic. Once you get used to your polarizers, you will hunt out pictures where your shoulder points to the sun. I like mine so much that I always keep a polarizer on every lens except the 21mm and the 200mm.

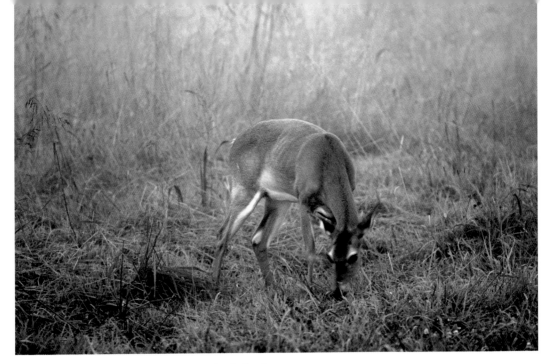

*Deer grazing at dusk along Hyatt Lane, in Cades Cove*

Depth of field is crucial to telling a story with your photograph. This is the amount of your image that is in focus from front to back. It increases as your aperture gets smaller and your shutter speed gets slower. (This means that slower shutter speeds yield sharper pictures—but only if you use a tripod.) A pro-quality camera should have a mode that allows you to preview this.

Finally, let's talk a little about exposure: that is, setting the aperture/f-stop. If your camera is less than 20 years old, it has a lot of complex gizmos that do this automatically—and if you don't understand all of them in detail, it will probably choose the wrong setting. I find it easier to turn all of this nonsense off and set the exposure manually. I do this by setting the exposure mode to "spot meter," which reads the correct exposure off a tiny spot at the center of the rangefinder. The trick is to know where to put the spot. For the Smokies, this turns out to be very easy: Green grass in full sunshine will always give the correct reading. Under the forest canopy in an overcast, use the leaf litter on the forest floor. You can also use a gray card (a piece of gray cardboard designed to give the perfect spot reading), but I've found metering off the grass to be far more reliable, as grass produces less glare than a piece of cardboard.

## Shooting Specific Subjects

Mountain views should be saved for brilliantly sunny days with low humidity and clear air—admittedly a problem in high summer (another reason, besides crowds and costs, to prefer the shoulder seasons of May, June, and September). Fall weather is superb for this. Spot-meter on grass, and lock in the exposure.

Forests, on the other hand, are best on cloudy days. Leave the sky out completely, use your polarizer, and concentrate on shape and color. For a sunny forest picture, wait for a high haze (not so rare here as elsewhere) to cut the contrast and reduce the mottling. Treat rivers

and waterfalls the same as forests, only use your slowest shutter speed and ISO as well as a polarizer; this will require a tripod, but will turn the churning water into a lovely blur. Spot-meter on forest litter; your automatic meter will invariably mess up on a waterfall's large areas of pure white glare.

Human artifacts—barns, log cabins, dams, whatever—fall somewhere in between. If you can get full, direct, polarized sun you will invariably end up with a superior picture. If you can't get that, try for full shade with no sky at all. Mixing sun and shade is possible, but difficult; use your spot meter to judge relative light values, being sure to place your composed image within the exposure range of your medium

(plus or minus two EVs for slide film, three EVs for negative film; for digital, check your manual).

## Practical Matters

The national park contains no hotels, cabins, restaurants, or gas stations. While it does have a large number of campgrounds, none of these has hookups, showers, or even electric lights in the restrooms. For nearly all travel facilities, you have to leave the park.

On the Tennessee side, travel facilities concentrate in three tourist towns. At the end of the Newfound Gap Road sits Gatlinburg, a substantial settlement wedged into a narrow gorge. This is the largest tourist town in the region,

*Rapids at Raven Fork in the Qualla Boundary countryside, near Cherokee*

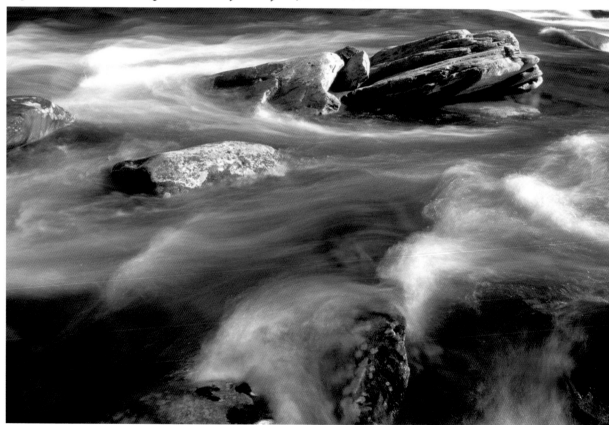

with the most motel rooms, restaurants, attractions, and golf courses. Densely built, it is perpetually traffic-jammed during the high season. Seven miles further north on US 441 is Pigeon Forge, home of the Dollywood theme park and a large collection of franchise motels and restaurants. Bed-and-breakfast inns are widely available in the surrounding countryside. To the west of Gatlinburg and Pigeon Forge lies Townsend, the smallest and most pleasant of the three towns, with a good selection of motels and cafés and the best access to the remarkable Cades Cove area of the park. In the Townsend area there are a number of very fine cabins for rent at reasonable prices.

Over the mountain, the town of Cherokee anchors the North Carolina end of the Newfound Gap Road, as well as the southern end of the Blue Ridge Parkway, the great scenic mountaintop drive that terminates, 469 miles later, at Virginia's Shenandoah National Park. Cherokee is the capital of the Eastern Band of the Cherokee Nation, the largest tribe in the eastern United States, with ten thousand enrolled members; its lands are known as the Qualla Boundary. Cherokee has many motel rooms and cafés, and some good cabin rentals. Its attractions include video gambling and some great museums and Native American art galleries; it has, however, an oddly retro and kitschy look, as if it were stuck in the 1950s. For B&Bs, first-rate hotels, and some really good restaurants you might want to look at the two nearby county seats of Bryson City and Sylva, both extremely handsome small towns and much more in the mountain spirit than any settlement yet mentioned. You'll find gas to be considerably cheaper on the Tennessee side.

If you want to stay inside the park, you have a choice of ten campgrounds, all of them scenic but primitive, with unheated restrooms, no showers, no electricity, and no hookups. Despite these conditions the campgrounds are extremely popular and fill up fast. You can get advanced reservations at the three most popular campgrounds: Cades Cove, Elkmont, and Smokemont. Of the remaining first-come first-serve facilities, Deep Creek is an excellent alternative to the Big Three, with a convenient location right outside Bryson City, a fair amount of room at 92 spaces, and some neat waterfalls. If you want remoteness the 12-site Abrams Creek is hard to beat; you may be two hours from Gatlinburg or Cherokee, but the campground is lovely and the fishing is great. But on a really hot summer's day, try to get into Balsam Mountain Campground on the Heintooga Spur Road—at 5,300 feet one of the coolest places in the park (and, indeed, in the South).

There are no restaurants inside the park. There are good places to eat along its borders in Gatlinburg, Townsend, and Bryson City, and the usual chains in Gatlinburg, Cherokee, and Pigeon Forge. My book *The Blue Ridge and Smoky Mountains: An Explorer's Guide* has complete listings of the best choices. There are no places to eat, good or otherwise, on the park's remote eastern or western edges; you'll want to pack a lunch, some snacks, and ample water. (Do not drink from streams or springs, as the disease organism giardia is rampant.) It's also a good idea to shove some high-protein snacks and a small canteen in your camera bag, in case you get peckish while walking to a photo site.

Dogs are prohibited in the national park's trails and backcountry, and are allowed in the picnic areas only on a short leash. Bicycles are also prohibited on the trails (except for Deep Creek near Bryson City), and the park roads are typically too busy for safe and pleasant cycling. The one notable exception is Cades Cove, where the loop road is closed to cars on Wednesday and Saturday mornings until 10:30 for the benefit of cyclists and walkers.

If you want a less civilized camping experience, the national park is a backpacker's paradise. Couch potatoes may be surprised to learn that backpacking in the Great Smoky Mountains National Park is so popular that it's been rationed since the Ford administration. The rationing system takes the shape of backcountry camping permits, required for all overnight trail use. The most popular backcountry areas require reservations and assigned camping spots, while the less visited areas have fewer restrictions. This system has succeeded in its goal of spreading backpackers throughout the park, instead of concentrating them by the hundreds along the Appalachian Trail. You can get a permit from any of the ranger stations, or by calling in advance of your trip.

Whenever you walk away from a park road you need to be watchful for the park's most deadly killers: hypothermia, dehydration, and exhaustion. Hypothermia—a sudden body cooling leading to disorientation—can occur even in the hottest weather when altitudes exceed 5,000 feet and massive thunderstorms blow up suddenly. And exhaustion and dehydration can occur regardless of body temperature, particularly when you're pulling up a 25-percent gradient that stretches for miles without a break. In either case, a disoriented person can wander off the trail—a very dangerous place to be in this twisted, craggy land. The park service posts a daily Web report on trail conditions, weather, trail closures, and bear locations.

Finally, a word on bears. The park's first-ever black bear fatality happened in March 2000, on the Little River Trail about four miles from Elkmont. In this incident, two bears attacked two adult hikers without apparent provocation, killing one and guarding the body as bears do a carcass they intend to eat, until rangers could arrive and kill the bears. Bears are very common and extremely dangerous.

They should never be approached or fed. Make enough noise as you hike the backcounty to alert bears to your presence. If one approaches you, face it and back away slowly.

## Where to Stay

If you want to photograph deer, consider camping in the park. Deer are most easily photographed in the great meadows of Cades Cove and Cataloochee Cove at dawn; elk are also readily found at dawn in Cataloochee Cove. Of the two, Cataloochee Cove's campground is nicer but much harder to reach, being at the end of the worst road in the park (and that is saying a lot). Cades Cove's campground has the extra advantage of accepting reservations.

That said, I personally prefer cabins for a photo trip, particularly the many fine cabins available in Townsend. A cabin gives me room to spread out my photo equipment, refrigerate my film, redo my camera bags, and repair my tripod—frequently from a big comfy sofa in a living room with a fire cackling in the background. If I stay out late photographing sunsets from a remote back road, I don't have to drag myself exhausted to a café, as I always keep something easy to prepare in the kitchen. I can also get out quickly in the morning with a tummy full of breakfast and coffee. And I find unwinding on a front porch with my wife, enjoying the stars and discussing tomorrow's plans, to be a big improvement over being jammed into a motel room. You'll find cabins to be price-competitive with the nearby tourist city motels, particularly when you factor in meals. For detailed descriptions, see my book *The Blue Ridge and Smoky Mountains: An Explorer's Guide.*

If you would rather spend your mornings enjoying a leisurely gourmet breakfast with your fellow travelers rather than chasing high mountain sunrises and dawn wildlife, try one of the many excellent bed-and-breakfasts on

either side of the park, and particularly around Bryson City. Again, you'll find descriptions in *The Blue Ridge and Smoky Mountains*.

## Smoky Mountain Seasons

In mountains this size, elevation is destiny: The Smokies are tall enough to make their own climate. At their feet in Tennessee, you'll find both elevations and temperatures little different from the rest of the Steamy South, but with considerably more overcast and rainfall. On the North Carolina side, the valley towns of Bryson City and Cherokee are a thousand feet higher than their Tennessee competitors, and therefore three to six degrees cooler. On some days this is significant, but on other days it is merely the difference between 88 degrees and 91 degrees. As you go up from these low points you'll feel the temperature drop about three to six degrees for every 1,000 feet you climb. The observation deck on Clingmans Dome should be 15 to 30 degrees cooler than downtown Pigeon Forge.

But it's not just temperature that changes between the foot and the crest of the Smokies— it's the entire climate. Pigeon Forge sits in the subtropical South, a climate zone that extends five hundred miles west, south, and east; it's characterized by mild, wet winters and very hot summers with frequent thunderstorms. You can drive from there to New Orleans, then to Orlando, then back, and never leave this climate zone—but drive 30 miles to the peak of Clingmans Dome, and you will, four climate

*Wildflowers along the Blue Ridge Parkway, near Cherokee*

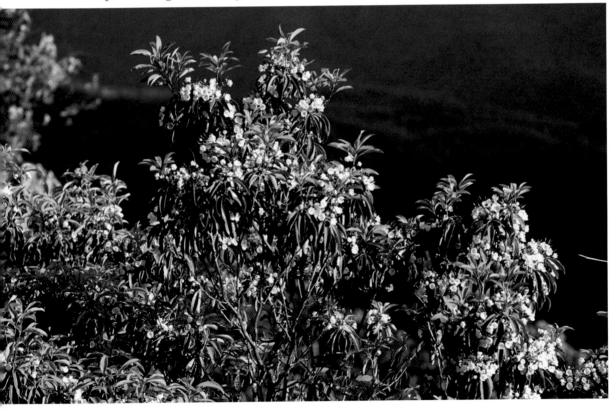

zones later, end up in a subarctic forest typical of Canada.

## Spring

Spring proceeds with painful slowness in the Smokies. In Pigeon Forge it starts at the normal time, with daffodils appearing the last week of March and the trees starting to leaf by early April. Up at Clingmans Dome at that time, spring is still six weeks away. Your photography of mountain vistas in early spring will be affected—perhaps "spoiled" is a better word—by the gray, leafless forests stretching along the upper altitudes. On the other hand, your chances for good wildflower photography are wonderful: With five climate zones and one of the richest temperate forests in the world, the variety is unmatched. Even better, you can adjust your schedule to match the blooming season, moving uphill for flowers that have normally bloomed by the time you arrive, and downhill for late bloomers. The City of Gatlinburg sponsors one of the nation's largest wildflower events in late April, with lectures and field walks over a three-day period.

The flowering understory trees are the showiest and most easily photographed of the park's wildflowers. Dogwoods appear early, just as leaves begin to show on the surrounding trees. The deep-magenta Catawba rhododendron appears after the dogwoods have faded; bushes within the forest will have isolated blooms, but bushes that receive direct sun will be covered in dense blossoms. The rhododendron bloom moves up the mountains, climaxing in early summer with stunning displays on the high grassy balds. Flame azaleas, bright orange on tall, spindly bushes, appear at the same time as the Catawba rhododendron.

Late May is one of the best times to photograph the Smokies. Your chance of clear, cool air is better now than any time before October, and rain is less common than it will be in the coming months. The trees are fully leafed, and wildflowers abound at all elevations.

## Summer

Summer starts with the Catawba rhododendron and flame azalea in full color on the high crests. At this time the pinkish rhododendron maximus and the strange little blossoms of the mountain laurel start to appear, beginning their month-long run. These fade by late August, leaving the white, splayed heads of Queen Anne's Lace as the dominant flower. Wild berries also become plump and colorful in early August, particularly that omnipresent weed, the wild blackberry.

The transition from spring to summer weather can occur anytime between the last week of May and the second week of July. Unlike spring, summer weather is dominated by still, hot air made unstable by uneven heating of the mile-high crests. High temperatures run around 90 degrees at Pigeon Forge and Townsend, and about 85 degrees in Bryson City and Cherokee. For relief from the heat, go higher up, where temperatures at the 6,000-foot elevations seldom reach 75 degrees. They get a lot of rain, though—thunderstorms, fundamentally unpredictable, blow up randomly and can drift in any direction. The Smokies crest catches the brunt of this, either generating the storm line or catching and holding storms that blow in from elsewhere. The humid air is hazy enough to obstruct views; there is frequently a gray layer that ends abruptly at around 5,000 feet, spoiling long-range views from the high peaks.

These are the typical conditions, but your results may vary. In one recent year we had brutal, hazy, 90- to 95-degree weather during the first week of June—and then had more than two weeks of crystalline air, barely reaching 80 degrees, in mid-July. It's largely a matter of luck.

*A man fishing in Deep Creek, along the trail to Indian Falls*

## Fall

Autumn is the most popular season for the Smokies, and little wonder. With more than 130 tree species, the mountains experience varied, abundant, long-lasting color. Altitude changes add to the variety, with color starting above 5,000 feet in early to mid-October, then gradually making its way downhill. Timing and coloration are, however, highly unpredictable, and the reasons poorly understood. In some years color starts late and slowly creeps downhill, so that the upper elevations go bare weeks before the deepest valleys reach full color. In other years, the whole range seems to burst into color within the same week for a short, spectacular display. In a "normal" year, color peaks around October 15, but when the weather continues warm and dry into September and October, expect a peak in late October and even mid-November.

Leaves are not the only source of color in the fall. Goldenrods and asters erupt in fields and meadows, while dogwoods give photographers a second chance with their colorful berries. Wildflowers and berries appear well in advance of the leaf change.

Sometime between early August and late September the summer's blue haze will end, giving way to piercingly clear air, intense colors, and unhindered visibility. When you rise in the morning, however, you may find yourself enveloped in a fog that can take until 10:00 to burn off. Do not let this discourage you, quite apart from the fact that fog is a fun photo subject. This is nearly always "valley fog," a common phenomenon in which cold air slides down off the peaks around dawn to pool in the valleys, causing a dense fog confined to the lowest elevations. Valley fog is a marvelous subject, easily captured from the Newfound Gap Road on the North Carolina side; other good sites are the Road to Nowhere, the Chilhowee Section of the Foothills Parkway, and the Blue Ridge Parkway (particularly Mile High Overlook and Waterrock Knob).

## Winter

Even in years with long-lasting fall foliage, the trees will be bare by mid-November. Significant accumulating snow can fall as early as Thanksgiving and as late as mid-April, but the best chances for good snow pictures are between late December and early March. Ground warmth is the culprit here: Most snows accumulate only a few inches and melt quickly, from the bottom up. In fact, sunlight on natural snow is quite rare, as cold weather events

nearly always have a large trail of overcast behind them that fails to clear until the snow is wet and spotty—or gone completely. A heavy snow event, followed by clear weather, is to be exploited aggressively. In many years, no such snow event happens.

As you would expect, the high crest of the Smokies is an exception. The area above a mile or so in elevation forms a high snow environment because it is always 15 to 30 degrees colder than the lowest valleys and because it gets double to triple the precipitation. Here, even more than the valleys, clouds linger and make photography difficult. Because of road closures, only two high-altitude locations can be reached by car. Newfound Gap is kept open in all but the worst snow events, thanks to a treaty with the Eastern Band; the road is not salted, however, and cars may be required to have four-wheel drive and chains. (And yes, someone will be there to check. Expect a queue.) No other park road is plowed, and most (including the Blue Ridge Parkway) are gated and locked; expect to have trouble parking, and then to walk a good distance to your target. US 19 in Soco Gap, in contrast, is always plowed and salted, and so is easily reached with your family sedan. It's only 700 feet lower than Newfound Gap, so the chance of snow is quite high. It's also a popular spot for families to take their kids for a bit of sledding—another opportunity for winter pics.

*Snow covers the countryside outside Cherokee*

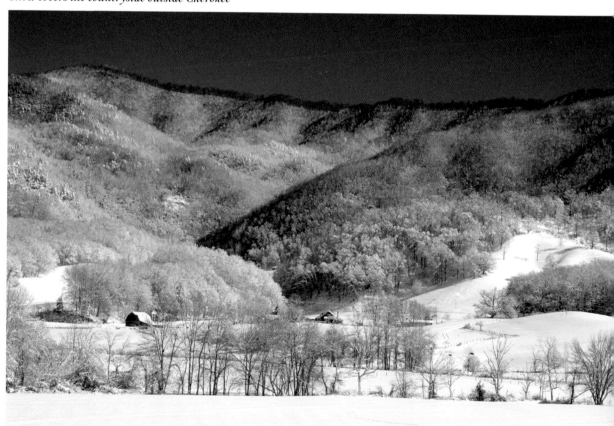

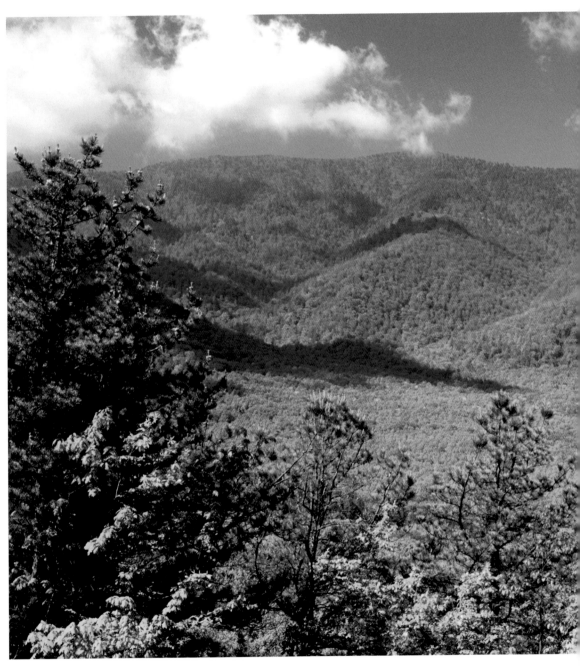

*View of the Smoky Mountain Front from the Lower Mount Cammerer Trail*

# The Northeast Quadrant

The Northeast Quadrant of the park is the most heavily visited, containing both the town of Gatlinburg and one of the park's most popular features, the Newfound Gap Road. Scenically, this quadrant is dominated by the massive front of the Smokies, here presenting the sharpest, steepest, and highest valley-to-peak gradient of any mountain in the eastern United States. Not surprisingly, this quadrant has the most old growth forest and the most unusual geological features. The four sections in this quadrant cover sites in and around Gatlinburg (including the town itself); Newfound Gap Road up to the crest of the Smokies; the Smoky Mountain Front (as we may call it) as it stretches east from Gatlinburg; and Big Creek, an isolated enclave of North Carolina at the far northeastern corner of the quadrant.

# I. Gatlinburg

**General Description:** The great majority of the ten million people who visit the Smokies every year get their first sight of the national park from the tourist town of Gatlinburg, Tennessee. With 3,800 full-time residents, this intensely busy collection of motels, restaurants, and shops straddles US 441 as it passes up a narrow valley and into the park. Brought into existence by the millions of visitors who have visited the park every year since the end of World War II, Gatlinburg tempts nature lovers away from the park with a carnival-like atmosphere. It also plays host to an exceptionally large and rewarding crafts community, with eighty or more resident craftspeople perpetuating mountain craft traditions. In contrast to all this hubbub is the tiny corner of the national park accessible from a downtown side street—Cherokee Orchards and the Roaring Fork Motor Nature Trail, with its quiet forests, log cabins, and waterfalls.

**Directions:** Approach Gatlinburg from I-40. If you are coming from the south or east, get off at exit 440 and take US 321 west for 27 miles. (Do not attempt to use the Newfound Gap Road, former US 441, as anything other than a scenic recreational drive.) If you are coming from the north or the west, leave I-40 at exit 407, then take TN 66 south, continuing on US 441 after 8.4 miles and reaching Gatlinburg in another 13.0 miles.

## Downtown Gatlinburg (1)

Gatlinburg is a city built for tourists. Originally it was just another poor mountain crossroads, a fork with a general store and a gas pump; then it became the terminus of the Newfound Gap Road in 1932, and the northern entrance

**Noted for:** A circuslike atmosphere, fine crafts, and the Roaring Fork Motor Nature Trail (5) leading from downtown into the park.

**Watch for:** Hucksters, high prices, and difficult parking. Traffic in Gatlinburg frequently gridlocks in summer; use the bypass (3) to reach the national park. Traffic lights are numbered, with the numbers actually hanging on signs over the intersections, to make directions easier.

**Facilities:** Full range of urban services. There are picnic tables and toilets at the town's Mynatt Park, on the approach road to Roaring Fork.

**Sleeps and Eats:** Literally thousands of rooms and a wide range of restaurants. See *The Blue Ridge and Smoky Mountains: An Explorer's Guide* for recommendations on cafés and B&Bs.

to the Great Smoky Mountains National Park in 1941. Today that mountain fork is a busy multilane intersection in the middle of a crowded downtown where two-story buildings, jammed against the sidewalk and each other, are filled with every sort of tourist enticement imaginable—gift shops, restaurants, candy shops, old-time photo places, side shows (labeled "museums" and "attractions"), amusement rides . . . you name it. Gatlinburg bears more than a passing resemblance to a large county fair, complete with bad parking, high prices, and a stiff dose of hucksterism. It's easy to complain about it, but it's a lot more fun to grab a corn dog and enjoy it. As a photographer, approach Gatlinburg as you would a county fair; look for outrageous or interesting buildings, unusual displays, and people enjoying themselves.

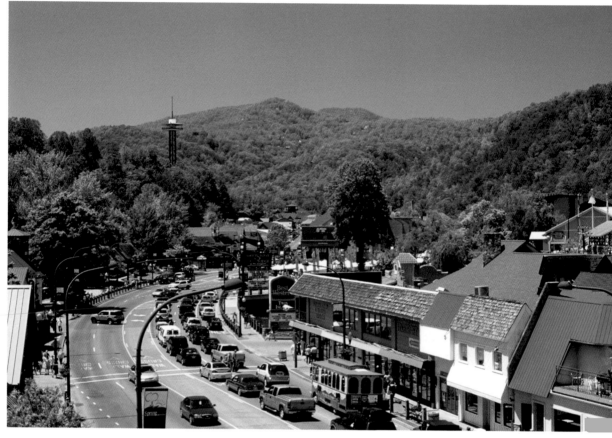

*Downtown Gatlinburg, viewed from the top of a parking garage*

Expect to have problems with traffic and parking. Gatlinburg traffic is always slow, and can grind to a stop during the summer tourist season. If you wish simply to reach the national park on other side, take the Gatlinburg Bypass (3), a scenic road maintained by the National Park Service. Apart from a limited number of street spaces along the river, downtown parking consists of a couple of expensive city garages plus an outdoor lot near the auditorium with a somewhat lower fee. As an alternative, you can park for free at the Welcome Center at the north end of town on US 441, or the City Hall at the east end of town on US 321, and take a trolley (cost: from $0.50 to $2.00).

### Crafters of the Glades (2)

This scenic rural cove on the east side of Gatlinburg has been a center for mountain crafts for over half a century. An 8-mile loop road, well signposted off US 321 three miles east of town, runs through the center of this crafters' community, becoming increasingly beautiful as it draws away from Gatlinburg's center; along it, small craft shops sit in meadows with views over the low mountains nearby. In 1937 the craft artists of the Glades formed their own association, the Great Smoky Arts and Crafts Community, limited to crafters who feature their own work in their own studios. There are now more than 80 such studio/

*A farmstead along a back road near the Glades*

galleries displaying the "Arts & Crafts Community" logo. According to member and porcelain artist Judy Baily, "People feel free to take their time in our shops. Many times they ask us a lot of questions about what we do, and we are glad to spend time with them." Talk with a crafter, and see what sort of conversation develops. Ask permission, then photograph the crafter in the studio environment.

North and east of the Glades the mountains are very low, but withsteep slopes and narrow, twisting valleys. Vacation development is surprisingly sparse in this zone, and the lanes that poke into its coves and hollows can be good places to scout for rural Appalachian shots.

## Overlooks on the Gatlinburg Bypass (3)

In the 1960s the National Park Service built this short scenic drive (3.6 miles long) so that you wouldn't have to stall out in traffic in the middle of downtown Gatlinburg on your visit to the national park. Half a century on, downtown Gatlinburg remains crowded and this bypass remains lightly used; as a photographer, however, you'll find it worthwhile even if it means driving out of your way. It's a gently curved forest drive, carefully designed to present you with no clue that you're really cutting across a large second-home development. Along the way are two views over Gatlinburg and the Smoky Mountain Front beyond, both

wide and spectacular. From these overlooks you can see how narrow and small Gatlinburg really is, and appreciate the vastness of the wall-like front. The mountain in the background is Mount Le Conte (17), and the slope from Gatlinburg to its peak is said to be the steepest and longest in the eastern United States.

## Bud Ogle Place, Cherokee Orchards (4)

Up until the early 1960s Cherokee Orchards, three miles south of Gatlinburg, was a commercial nursery and apple orchard; it's now inside the national park, cleared of structures and abandoned to forests. One structure remains: the Bud Ogle Place, a fine log cabin with a large barn, set in a glorious display of wildflowers. The Ogle Place is unusual in that Bud rigged a running water system into his cabin, using hollowed-out tree trunks to pipe water from a nearby stream. The adjacent nature trail explores the forests that have grown up on the abandoned farmlands. You can reach it from downtown Gatlinburg, turning at Light #8 and following the road straight ahead into the national park; the cabin is 2 miles farther. (The Rainbow Falls trailhead (10) is a half mile beyond the Ogle Cabin, and the entrance to the **Roaring Fork Nature Trail (5)** is three-quarters of a mile after the Ogle Cabin.)

## Roaring Fork Motor Nature Trail (5–9)

This nature trail for the auto-bound wanders down old farm roads that once reached into a well-settled area of small farms south of

*Gatlinburg, viewed from the Gatlinburg Bypass*

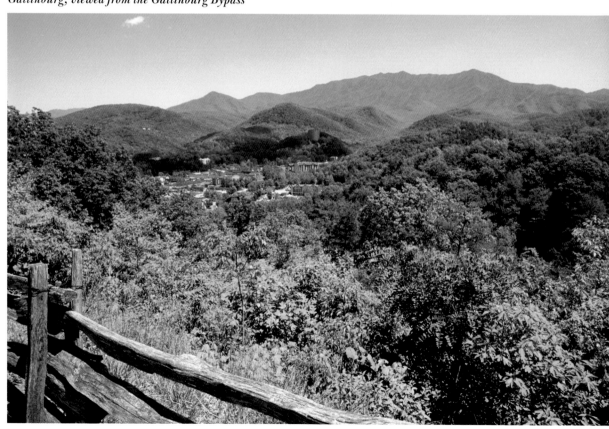

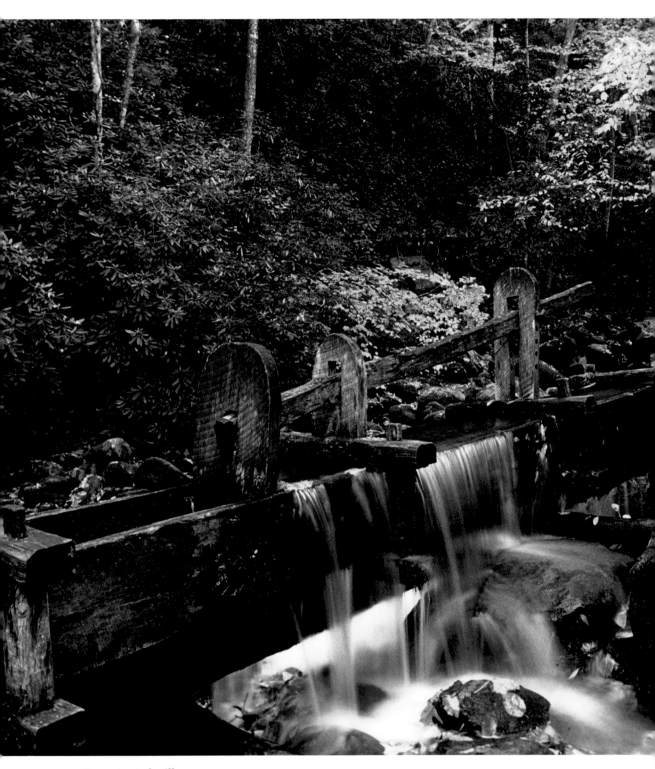

*Reconstructed mill race*

Gatlinburg, now gone back to forests. It's one lane wide and one-way, so there is no turning around and no getting around; if anyone in your party needs a restroom, return to Gatlinburg now. (There are facilities at Mynatt Park, outside the national park gate.)

The drive starts in Cherokee Orchards at the top of the road, 0.7 miles beyond the Bud Ogle Place (4). Passing the Baskins Creek Trail (11) after 0.2 miles, the road twists up to a ridge with a good view, then twists around to a second ridgeline with a great view westward (5) toward Sugarlands, with receding ridges fading into the background. Passing the Grotto Falls trailhead (12), the road twists through a hemlock forest, then follows a boisterous creek; look for the stone wall on the opposite side. After a half mile, a parking lot will mark the far end of the Baskins Creek Trail and the **Jim Bales Place (6)**, a log cabin and outbuildings overlooking a small waterfall. Then the road reaches the **Ephraim Bales Place (7)**, a modest dogtrot log cabin and barn, with an impressive stone wall marking the location of the old farm road. A half mile farther the road passes the last and most colorful of the four sites, the brightly painted **Alfred Regan Place (8)**, with a restored horizontal wheel "tub mill" by the stream. A double stream crossing marks the point where the creek drops suddenly into a small gorge, with the road following it on a ledge hewn into the rocky slopes above. Here are dramatic views down the stream and two wonderful waterfalls, known as the **Place of a Thousand Drips (9)**, trickling down the rocks above the road. The road finally leaves the park to re-enter Gatlinburg, emerging onto US 321 a few blocks east of town center.

### Waterfalls of the Roaring Fork Motor Nature Trail (10–12)

Apart from the Place of a Thousand Drips (9), there are three additional worthwhile waterfalls

along your drive through Roaring Fork Motor Nature Trail. The first, with the most difficult walk, is **Rainbow Falls (10)**, in Cherokee Orchards (a half mile past the Bud Ogle Place (4) and a quarter mile short of the entrance to the Roaring Fork Motor Nature Trail). Here Le Conte Creek leaps over an overhanging cliff to plunge 80 feet, said to be the tallest drop within the national park; there's an excellent photo angle from the trail. The hike to the falls, however, is a steady, unrelenting slog upwards, with an elevation gain of 1,750 feet in 2.6 miles (for a round trip of 5.2 miles). The next waterfall, the little-visited **Baskins Falls (11)**, is your best chance for solitude, probably because the directions are complex. Park just outside the Roaring Fork Nature Trail and walk along the trail for 0.2 miles, then turn left onto Baskins Creek Trail. Follow the trail for 1.2 miles (with 200 feet of climb and 700 feet of descent) to a left fork, which leads to the falls. Return the way you came, or continue along the main path for 1.4 miles (with 500 feet of climb and 300 feet of descent) to the Jim Bales Place (6). Popular **Grotto Falls (12)** is the easiest to reach of the three waterfalls, an attractive walk of 1.3 miles (one way, climbing 750 feet) on Trillium Gap Trail, here an old roadbed. Grotto Falls, about 25 feet tall, flows over an overhang so wide that the trail passes beneath it.

*Grotto Falls*

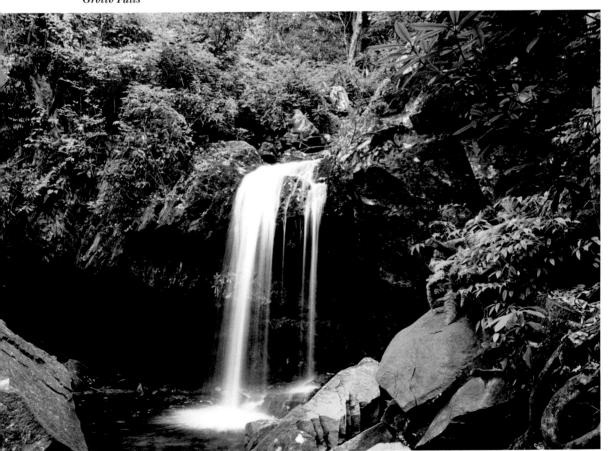

# II. Newfound Gap Road: Tennessee

> **Noted for:** Forests, views, hiking trails.
> **Watch for:** Heavy, slow traffic and no passing. Bears along the roadside create traffic jams and are hazardous to approach.
> **Facilities:** Sugarlands Visitors Center (13), at the start of the road, has restrooms, a museum, and gift and book shops. There's a picnic area with restrooms at Chimneys, 4.4 miles south of Sugarlands Visitors Center. Newfound Gap Overlook (19) has restrooms but no picnicking.
> **Sleeps and Eats:** Both are available in Gatlinburg (1) or Cherokee (32). The nearest national park campground is Elkmont (72).

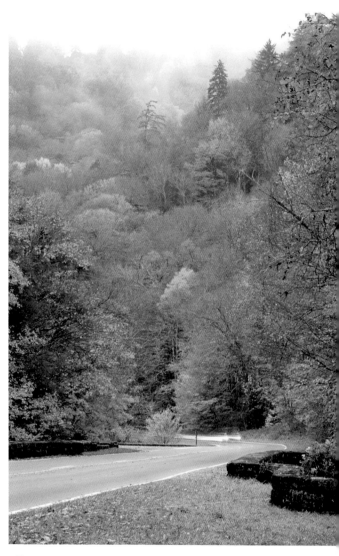

*The Newfound Gap Road at Walter Camp Prong*

**General Description:** US 441 loses its route number at the national park boundary; from here until it exits the park at Cherokee, North Carolina, it's the Newfound Gap Road, maintained by the National Park Service. It's the only road that crosses the Smokies, taking 15 miles to climb the steepest mountain face in the East, topping out at 5,046 foot Newfound Gap, then dropping 17 miles to Cherokee. This section describes some of the best photo opportunities along that climb, including Newfound Gap itself; the descent to Cherokee is described in the Cherokee section in Part II (Southeast Quadrant) and includes the spur road to Clingmans Dome.

**Directions:** Take US 441 south through downtown Gatlinburg, continuing on Newfound Gap Road at the park boundary.

## Sugarlands Visitor Center (13)

The Sugarlands Visitor Center (1.7 miles from the national park border) is the largest such facility in the park, with a natural history

museum, a film presentation, an information desk, and a book and gift shop. The building itself is a fairly ordinary structure from the early 1960s and tends to be crowded. A short walk behind it is the park's handsome administrative compound, a classic example of the simple, elegant architecture favored by New Deal relief agencies in the 1930s. The highlight, however, is the little-visited Fighting Creek Nature Trail, starting at the back left corner of the center. It leads through abandoned, overgrown farmlands, complete with settlement remains, to a restored log cabin.

## Campbell Overlook (14)

At 3.9 miles from the national park border, Campbell Overlook, with two separate parking lots on your left, gives one of the finest views of Mount Le Conte, the tallest (above its valley floor) and steepest mountain in the East. In between you and the mountain lies the valley known as the Sugarlands, once heavily settled and noted for its poverty and moonshine, now covered in a handsome young forest. This is a good place to try a panorama; level your tripod head, then shoot the scene with a normal (50mm) lens, rotating it and overlapping the

*Panoramic view of Mount Le Conte from Campbell Overlook*

shots at least 30 percent. Special software will help you stitch the pictures together; in Photoshop, select File/Automate/Photomerge.

## Chimney Tops Trail (15)

As you climb up from Campbell Overlook, at 6.2 miles from the national park border you'll pass the Chimneys Picnic Area, a good place for stream pictures. At At 8.6 miles you'll reach the trailhead for Chimney Tops, two isolated needles of bedrock sticking out above the trees, high above the gorgelike valley of the Pigeon River that you've been following. The popular hike to the top of the higher and closer of the two is a 2-mile trudge that gains 1,300 feet in elevation. The views are rewarding, however, with a full 180-degree panorama over the Newfound Gap Road and Mount Le Conte behind it. This is the best place to photograph the 360-degree pigtail in the Newfound Gap Road (at 8.8 miles, just below you), known simply as "The Loop." Bear in mind that, unless you are conditioned to mountain walking, it could take you two hours to reach the top, and that the Newfound Gap Road will be in deep shade hours before sunset.

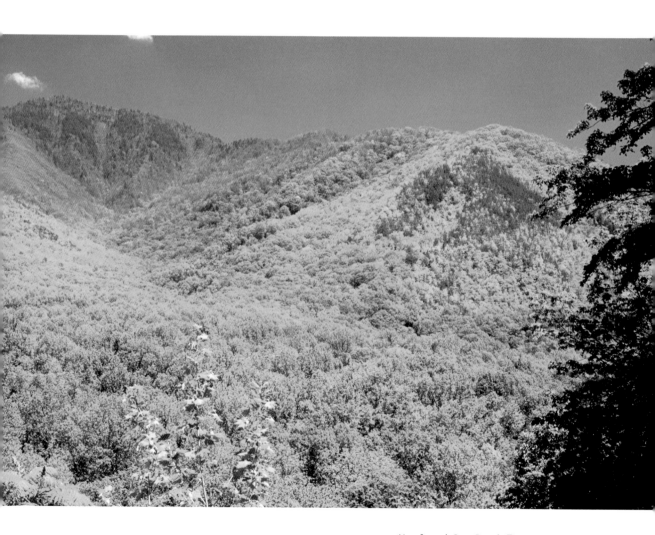

*Stream view from Walter Camp Prong*

### Alum Cave Trail (16)

As you drive around the pigtail curve known as The Loop, you climb (at 9.1 miles from the park border) up to the narrow, perched valley of Walter Camp Prong, a 1.5-mile stretch that has some good places to pull over for pictures of both the stream and the road. Along this stretch (at 10.2 miles) a parking area on your left marks the trailhead for Alum Cave Trail,

one of the park's most interesting walks. It leads after 2.1 miles (climbing 1,400 feet) to an exposed rock bluff with such a large overhang as to form a a sort of cave, with the trail going through it. The views here, west and south over the Pigeon River gorge to the Smokies crest, are spectacular; you are now at 5,200 feet, yet much of the mountain is still above you. The trail leads on, with more fine views and good scenery, to Mount Le Conte (17).

### Mount Le Conte (17)

Mount Le Conte (6,593 feet) is less than 6 miles from downtown Gatlinburg, yet it has a vertical rise of 5,300 feet—the steepest and tallest such rise in the East. For many that's reason enough to climb it, and there are five paths to the summit. Even better, you don't have to pack a tent or meals; there's a log cabin lodge at the top, supplied by llama trains that ascend via Trillium Gap Trail (12). Reservations are required and hard to come by, but once you're signed up you get a roof over your head, a bed with linens, and two hot meals. Views are excellent, particularly from the chutes-and-ladders Cliff Trail, and noted for their sunrises and sunsets. Alum Caves Trail (16) is the least difficult way up (4.6 miles, with 2,600 feet of climb). For the best photography, however, consider taking the Appalachian Trail from Newfound Gap (19) to the Boulevard Trail, noted for its views, spruce forests, and high altitude wildflowers (7.6 miles, with 3,000 feet of climb and 1,500 feet of drop), then returning the next day via Alum Cave Trail.

### Morton Overlook (18)

At 13.9 miles from the national park border, Morton Overlook (coming up almost blind on your right) offers a fine view straight down the gorge of the Pigeon River. The view is predominantly west, with the crest of the Smokies visible on your left. You'll want to hit this in the

morning to avoid having the sun in your lens, or at sunset, when (near midsummer) the sun will dip down into the valley below you.

## Newfound Gap (19)

You'll find the high point of the Newfound Gap Road (14.7 miles from the national park border) to be a large parking lot lined with massive granite walls, with a huge granite pulpit at one end built for President Franklin Roosevelt's dedicatory speech in 1941. The Appalachian Trail runs right below this monument. The best views, however, are from the far southern end, southward into North Carolina; here you can see the Newfound Gap Road running along a side ridge, then descending the steep slope below you. The Clingmans Dome Spur Road (44) is 200 yards beyond Newfound Gap on your right; continuing straight, the Newfound Gap Road reaches Oconaluftee Valley Overlook (43) in 0.7 miles from Newfound Gap, and the overlooks of Thomas Divide (42) in 1.8 miles from Newfound Gap.

## Charlie's Bunion (20)

This impressive cliff, black, rough, and broken, projects outward from the crest of the Smokies 4.3 miles from Newfound Gap, eastward along the Appalachian Trail (with about 1,500 feet of climb and descent each way). It's entirely man-made, the result of an environmental catastrophe. In 1925 massive brush piles left by clear-cut loggers caught fire so severely that it not only killed all vegetation but burned and scorched the soil itself, killing the seeds. Four years later, when torrential rains hit, the ground was still bare and simply washed away to bedrock, exposing this cliff. Mountain writer Horace Kephart discovered the site a few days later and named it for the aching feet of Charlie Conners, one of his companions. The trail to the Bunion has ample views and wildflowers along the way, and the Bunion itself is one of

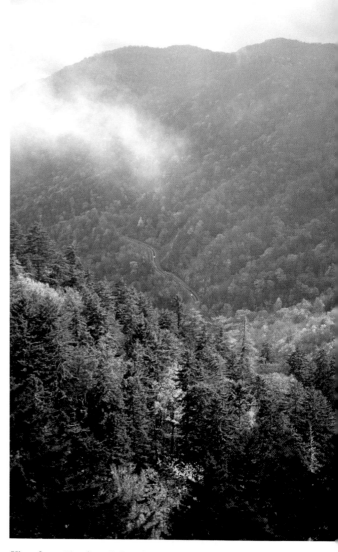

*View from Newfound Gap into North Carolina, showing Newfound Gap Road descending the mountain*

the great sights of the Smokies. When you are done with it, continue a short distance ahead to the gap and circle behind the knob through wildflower meadows (also left by the fire), with wide views over the receding mountains of North Carolina's Blue Ridge region.

*Path following a former road in Cosby Recreation Area*

# III. The Smoky Mountain Front

Noted for: Dramatic mountain wall, old-growth forests.

Watch for: There are no special difficulties in this area.

Facilities: Greenbrier Cove has picnicking and restrooms. Cosby has picnicking, camping, and restrooms.

Sleeps and Eats: Cafés and motels stretch along US 321 from Gatlinburg.

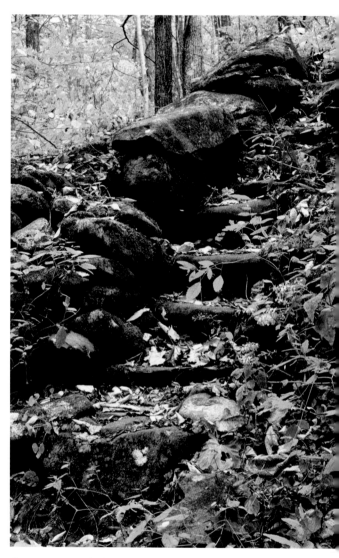

*Stone steps mark the site of an old farmstead in Porters Flats*

**General Description:** As the Smokies stretch eastward from Gatlinburg they present an impressive wall, a mountain front that climbs 4,000 to 5,000 feet above its valley floor in a linear distance of about 7 miles. This rugged section escaped some of the destructive logging of the early twentieth century, so it contains some fine old-growth stands. It also holds settlement remains and a popular waterfall. Its main feature, however, is the mountain wall itself, and this section will highlight a couple of places to capture the wall in all its glory.

**Directions:** Take US 321 east from Gatlinburg; this stretch is about 20 miles long.

## Porters Flats (21)

This Greenbrier Cove walk explores an abandoned farming community and the old-growth forest behind it, and is particularly good for an overcast day. To reach it, go 5.9 miles east of Gatlinburg on US 321, then right into the national park on Greenbrier Cove Road (becoming gravel after 1.5 miles). Turn right at the fork after 3.1 miles, then continue 0.9 miles to the end. From here a level one-mile walk along an old road leads you past some handsome and photogenic settlement remains to a log farmstead hidden in the trees to your right, not particularly authentic but making for good photography nonetheless. From here, continue past the road's end to Porters Creek Trail on your left, which follows its namesake gently

uphill and into a virgin forest. The walk remains gentle for another half mile, then crosses the stream and enter the old-growth zone; there's a handsome waterfall on your left at 1.8 miles, a good destination. The path dead-ends at the mountain wall in another two miles.

### Ramsay Cascades (22)

Like Porters Flats (21), Ramsey Cascades is also part of the Greenbrier Cove area; follow its directions to the fork, then turn left (over an attractive bridge, worth shooting) and continue 1.6 miles to the end. This is one of the most popular and heavily visited waterfalls in the national park, a steep 3.7-mile hike (climbing 1,200 feet, mainly in its last two miles). Expect this to be more of a social than a wilderness experience. As its name implies, this waterfall breaks over numerous rocks on its precipitous 80-foot plunge, and makes a good

photo subject—as does the old-growth forest that surrounds it. This is another good one for a cloudy day.

### Albright Grove (23)

Named after a National Park Service administrator who did much to ensure the park's integrity from developers, Albright Grove is a remarkable stand of virgin old-growth forest. It's a stiff hike, 6.7 miles round trip with 1,600 feet of uphill climb, all through forest; and, as it's all under shade, you'll want to save it for an overcast day. The trailhead is hard to find. Go 15.5 miles east of downtown Gatlinburg on US 321, then turn right onto Baxter Road, by Smoky Mountain Creekside Rentals; from there, turn right at the T intersection with Laurel Springs Road, going a short distance until you reach the park service sign for the Maddron Bald Trail. Hike uphill on the Mad-

*A stream along Lower Mount Cammerer Trail*

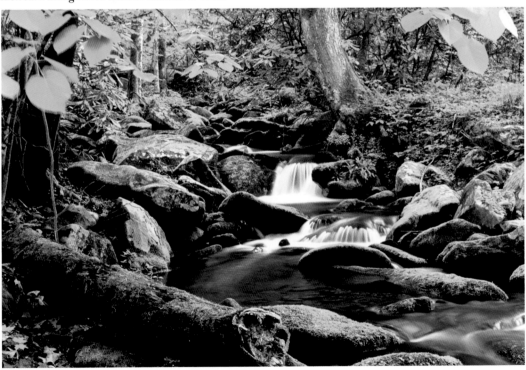

dron Bald Trail for 3 miles to reach Albright Grove, mostly along an old settlement road through second-growth forests on former farms. After a half mile you will pass one of the old farm houses, a chestnut log cabin with a shake roof, a good photo subject. After 2 miles the overgrown farms end and you start entering old forests dominated by large hemlocks— a classic Appalachian cove hardwood forest, with a rich variety of old, large trees. At 2.8 miles, the Albright Grove Loop Trail forks right to enter a segment of the forest that has never been logged. In all, the loop trail leads through this cathedral-like forest for 0.7 miles before returning to the Maddron Bald Trail.

## Cosby Recreation Area (24–25)

About 20 miles east of Gatlinburg (US 321 east 18 miles to a right turn on TN 32, then 1.1 miles to a right onto Cosby Park Road), this recreation area inside the national park occupies a former Civilian Conservation Corps camp. Look for shots along the mile-long **Cosby Park Road (24)**, both for the forests, which show well in fall colors, and the stream. There's a picnic area here, and a large campground. The best shots, however, are along the **Lower Mount Cammerer Trail (25)**, a comparatively easy walk (1.4 miles, 400 feet of climb) along old settlement roads, with a goodly number of photo subjects along the way. As the trail reaches a small ridge you'll come up to one of the best views of the park on your left, as the Smoky Mountain Front suddenly looms in front of you. Although the trail continues to the crest of the Smokies (in 5.3 miles, with 900 feet of climb), this is a good place to turn around.

## Foothills Parkway East (26)

Congress created the Foothills Parkway in 1944 as a consolation prize to Tennessee, which had wanted the Blue Ridge Parkway but lost out to North Carolina. The parkway was supposed to

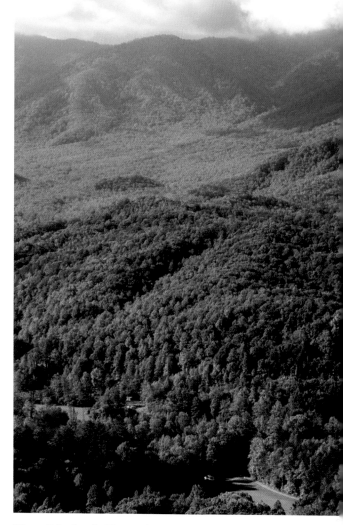

*View of the Smoky Mountain Front from the Foothills Parkway East*

arc around the Great Smoky Mountains National Park, but, while it still remains fitfully under construction, only two sections have ever been opened. This eastern section links I-40's exit 443 with US 321 at Cosby, a distance of 5.8 miles and a nice shortcut if you are driving between Gatlinburg and North Carolina. For the photographer, there are some superb views of the Smoky Mountain Front from an overlook 3.9 miles from the interstate, with striking light in the late afternoon.

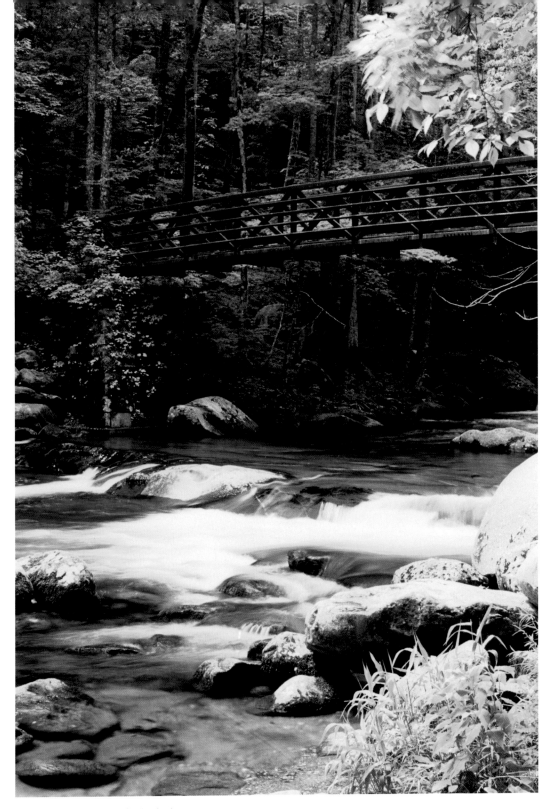

*Footbridge in Big Creek Picnic Area*

# IV. Big Creek

**Noted for:** Mountain river, waterfalls, interesting rural village.

**Watch for:** There is no gas and no eatery in the area. TN 32 between Cosby and Big Creek is a poor road due to an extreme number of curves.

**Facilities:** Picnicking and restrooms at Big Creek. Pay phone at Big Creek Ranger Station.

**Sleeps and Eats:** In Gatlinburg, 35 miles west via I-40 and US 321.

*Old farmhouse in Waterville*

**General Description:** This short section takes in an isolated nook of North Carolina nestled between the Smokies and a major side ridge, the 5,800-foot Mount Stirling Ridge. The area is more easily reached from Tennessee than from North Carolina, hence its inclusion in the Northeast Quadrant. The western half, within the national park, is a classic V-shape valley carved by lively Big Creek, noted for its rapids, waterfalls, and swimming holes. It's extremely popular with horseback riders. The eastern half, between the national park and I-40, is mountainous farmland, remote and handsome. Its major feature is the photogenic hydropower village of Waterville.

**Directions:** Your mapping software will probably tell you to take US 321 east from Gatlinburg, then turn onto NC 32. Ignore it—NC 32 is a dreadful drive, filled with pointlessly tight curves. Instead, go beyond it to the Foothills Parkway East, then along the parkway to I-40, then south on I-40 to exit 451, then south on Waterville Road for 2.1 miles to the national park, a total of 35 miles. From all other directions, use exit 451 from I-40.

*Big Creek*

### Big Creek Picnic Area (27)

This small and pleasant picnic area, 0.8 miles into the national park, is a major trailhead for the northeastern backcountry. It was originally an early-twentieth-century lumber town named Crestmont, relics of which are said to be visible near the Big Creek trailhead. The best photo site is at the Baxter Creek trailhead in the middle of the picnic area; here a long steel bridge crosses Big Creek to terminates at a cliff-like bluff. The creekside is worth exploring, particularly if you lack the time or inclination for an extended hike upstream.

### Big Creek Trail (28–30)

This trail, a good day walk, follows an old railroad grade upstream along Big Creek. It's popular with horseback riders, so watch where you put your feet. Logging ended by 1918, so the forests are mature and handsome and the creekside scenery attractive—a good destination for a cloudy day. At 1.4 miles the creek flows through a small waterfall to form **Midnight Hole (28)**, a large, deep pool, attractive in itself and a popular swimming hole. At 2.1 miles, Mouse Creek flows into Big Creek over a smooth rock bluff, creating the 20-foot

**Mouse Creek Falls (29)**, easily photographed from the trail. At 2.2 miles another pool is visible from a trail bridge, followed a section of trail dynamited out of the rock when the railroad was built; creek views are good here. At 2.8 miles you'll reach **Brakeshoe Spring (30)**, a good place to explore some of the more intimate details of water, rock, and cliff. The trail continues another 3.1 miles to the creek's headwaters and a junction with other backcountry paths.

## Waterville (31)

The village of Waterville sits beside a hydro generator plant; leave I-40 at exit 451 and go 1.3 miles south on Waterville Road. The plant is an interesting subject, an industrial Gothic structure from 1927; it's fed from Walters Lake (no access), 12 miles upstream, by a massive pipeline that plunges into the plant from above.

*Recently hatched butterflies dry their wings on a creekside rock in the picnic area.*

*Power plant in Waterville*

There's a nice little park uphill from the power plant, and a path that leads steeply uphill above the plant for good views over it. Uphill from that is the village itself, built in 1927 by Carolina Power & Light as a model village for construction workers; it's a fine collection of period vernacular architecture, well maintained and centered on a footbridge made of plate iron.

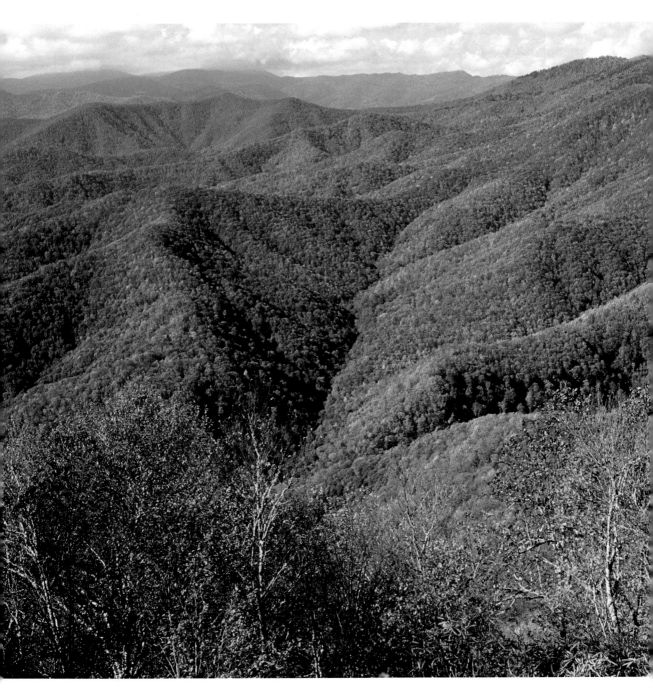

*View of the Great Smoky Mountains from Mile High Overlook*

# The Southeast Quadrant

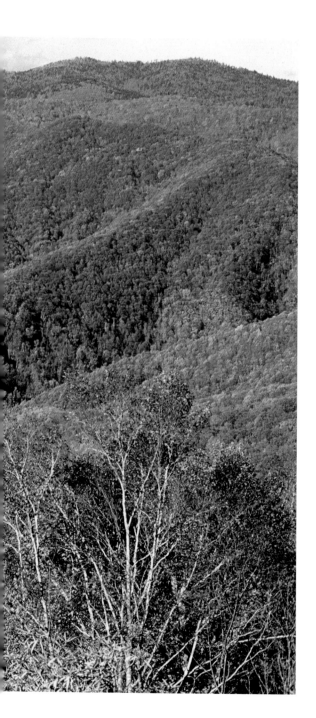

The park's Southeast Quadrant, located in North Carolina, is a land of twisting, high ridge lines and V-shaped valleys, heavily forested and reached mainly by long hikes. The lands of the Eastern Band of the Cherokee Nation, correctly known as the Qualla Boundary, abut the national park's southern border, and its capital, Cherokee, is this quadrant's main service center. Cherokee is a densely packed tourist settlement along US 441 at the south end of Newfound Gap Road, smaller and less crowded than Gatlinburg, with a very distinctive character. The southern terminus of the Blue Ridge Parkway is here, the first thing you come across as you drive north along the Newfound Gap Road from Cherokee. At the southeastern corner of the park is the remote Cataloochee Cove, intentionally maintained in its pre-park meadows and dotted with preserved mountain farm buildings, but reachable only by very bad gravel roads and little visited.

*A farm gate at dusk, near Cherokee*

# V. Cherokee

**General Description:** The capital of the Eastern Band of the Cherokee Nation, straddling US 441 at the southern terminus of Newfound Gap Road, presents to the park visitor a string of 1950s-style gift shops, attractions, motels, and restaurants, packed one building thick along the main highways. For the serious visitor, tribal museums give an accurate picture of Cherokee history.

**Directions:** Cherokee is best approached from the south, via US 441 and US 74, both high-speed multilane highways; US 19 from the east is a narrow, twisting, steep mountain road and best avoided. If you are coming from Gatlin-

> **Noted for:** Excellent museums, authentic Cherokee craft art, souvenir stands, tin teepees, stuffed bears on wheels, roadside chiefs, and video gambling.
> **Watch for:** Gasoline is more expensive here than in Gatlinburg. Traffic can be very bad.
> **Facilities:** Picnicking and restrooms at Oconaluftee Islands (33), and at Collins Creek on Newfound Road, 6.4 miles north of the park border.
> **Sleeps and Eats:** Many motels and restaurants in Cherokee. For bed-and-breakfast accommodations or fine dining, try Bryson City (Part IV) or Sylva.

*Museum of the Cherokee*

burg, Newfound Gap Road is crowded, steep, and slow; allot two hours for the drive during the summer season, even though the distance is only about 30 miles.

## Town of Cherokee (32)

The main administrative center of the Qualla Boundary since the nineteenth century, Cherokee sits astride US 19 and US 441, hard against the national park's southern boundary. It's much smaller and more modest than Gatlinburg, and its parking and traffic isn't quite so bad. Much of its modest appearance is due to land restrictions within the Qualla Boundary, which have kept Cherokee in sort of a 1950s time warp.

Here's the layout: US 441 goes north and south, while US 19 goes east and west. Cherokee sits at their intersection, with modest businesses stringing outward along these highways. The most densely developed area, called "Downtown Cherokee" on road signs, straddles US 19 just east of US 441. Compared to

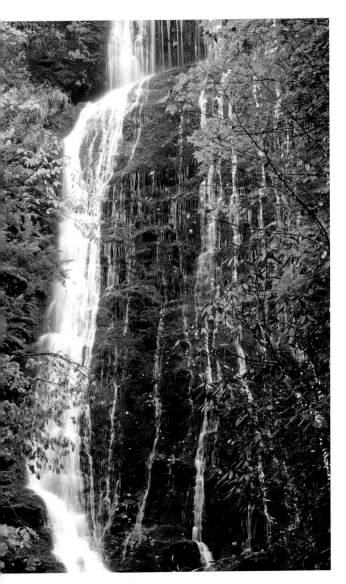

*Mingo Falls*

sit on flat 1950s roofs, and totem poles hold up porches. "Roadside chiefs" dress up like Great Plains Indians and sit in front of fake teepees. It's fun to photograph, but don't forget that the "chiefs" make their living by charging to have their picture taken.

The real center of Cherokee gathers around its government complex on US 441, about a mile north of downtown. The museums are meant for serious visitors just as "Downtown" is meant for clueless types. Here you'll find a first-rate history museum and the Eastern Band's craft cooperative, as well as the Cherokee Historical Association's outdoor drama *Unto These Hills,* which tells the story of the tribe's defining moment, the Trail of Tears.

Finally, at the far end of town just before the national park entrance, is another agglomeration for the gormless, also colorfully tacky but more modern, and therefore less photogenic, than downtown.

### Oconaluftee Island Tribal Park (33)
Isolated from the center of Cherokee by the waters of the Oconaluftee, Islands Park is an oasis of cool, quiet loveliness. Its picnic tables are widely scattered through a forested glade, and linked by an interpretive nature and history trail. Should Cherokee start feeling like much of a muchness, taking a few shots here of the lovely Oconaluftee will restore your equilibrium.

### Oconaluftee Indian Village (34)
This living history museum, owned by the tribe, recreates an authentic eighteenth-century village. The village itself is a simple grouping of log structures, as would be most such settlements in this period. (Downtown aside, the Cherokees did not use teepees.) The main attraction is the costumed interpreters, who demonstrate a variety of period crafts and perform sacred dances. You start with a guided

the Tennessee tourist towns, "Downtown Cherokee" is startlingly retro, with a look and feel that's changed surprisingly little since the early days of park tourism. Old-fashioned open-front souvenir stands, bursting with an astonishing variety of trinkets, still predominate. Shops trundle out stuffed bears on wheeled platforms, giant sheet-metal teepees

tour, after which you are free to wander around, talk with the crafters, and take photos. Adjacent is a botanic garden featuring native garden and medicinal plants.

Open daily 9–5, May–Oct. Adults: $15; children: $6. Call 866-554-4557, or visit www .cherokee-nc.com.

## Mingo Falls (35)

One of the most beautiful waterfalls in the Smokies, Mingo Falls is the highlight of a tribal park and campground in Big Cove. A short, steep track leads a quarter mile uphill to the base of the falls, a lacy curtain of water hung over a hundred-foot cliff. There are many good angles here, and the sheet of water over the dark-gray rock allows an almost Japanese effect. You'll find the falls six miles north of Cherokee on Big Cove Road; turn left at Saunooke Village, then just keep going.

There's some good countryside photography along the Big Cove Road as well. The best scenic farmland, however, is south of the town of Cherokee, down the lanes that penetrate both sides of US 441 to its intersection with US 74.

*A rural church in snow, near Cherokee*

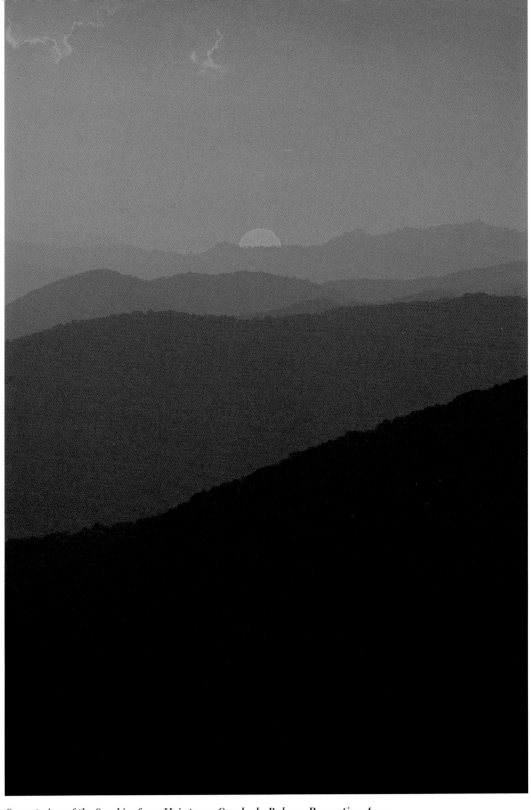

*Sunset view of the Smokies from Heintooga Overlook, Balsam Recreation Area*

# VI. Blue Ridge Parkway

**Noted for:** Dramatic views of the Smokies; spring azaleas and rhododendrons in profusion.

**Watch for:** There's no gasoline anywhere along the parkway; if you start to run out, return to Cherokee the way you came.

**Facilities:** Picnic area, national park campground, and restrooms at Balsam Recreation Area.

**Sleeps and Eats:** In Cherokee. National park campground at Balsam Recreation Area, the highest and coolest in the park.

**More Information:** *The Photographer's Guide to the Blue Ridge Parkway* has detailed information on the entire drive from here to milepost 0.

*Dusk view over the Qualla Boundary from Ballhoot Scar Overlook, Blue Ridge Parkway*

**General Description:** The National Park Service's Blue Ridge Parkway stretches 469 miles along the eastern backbone of the Appalachians, from Shenandoah National Park in Virginia to here, 0.8 miles north of Cherokee on the Newfound Gap Road. Not only is it one of the nation's great driving experiences, it's probably unique in the world: a long, artfully landscaped mountaintop drive with no major cross streets and no stops at all, its scenery both created and shielded by a 1,000-foot-wide right-of-way. This section, officially the last on the parkway (look for mileposts 469 to 456 on your left), is as good as any. Look not only for the standard views but also for roadside scenery, including the handsomely designed man-made features—signs, tunnels, abutments, and the like.

While this book describes only the first few miles, you can make an easy loop by extending your drive to milepost 442, Balsam Gap; from there return via the easy multilane highways US 74 west to US 441 north.

**Directions:** This section of the parkway starts just inside the national park borders on

Newfound Gap Road, and extends 11 miles to the Heintooga Spur Road. Return the way you came, or via US 19 at Soco Gap (milepost 456), then west 12 miles to Cherokee.

### Start of the Parkway (36)

Pick up the parkway on your right, just inside the national park on the Newfound Gap Road. You are almost instantly rewarded with a fine view over the Oconaluftee Mountain Farm Museum (39). You'll have four more overlooks in the next six miles, each one facing north or northwest and offering a different perspective on the Smokies crest and its mighty side ridges. You'll also start a series of tunnels, five in all; parkway tunnels can be good subjects if you can get full sunlight on their faces and some sort of framing. If you are lucky enough to be driving this section between mid-May and late June look for a spectacular display of purple

Catawba rhododendrons and the appropriately named flame azalea, sometimes in large masses, and increasing as you gain in elevation. This section ends at the Heintooga Ridge Spur Road—a left turn at milepost 458.2, at a point 3,200 feet higher than Cherokee.

### Heintooga Spur Road (37–38)

This pleasant side road of the Blue Ridge Parkway follows a high mountain crest for 8.9 miles, going deep into the national park. The pavement terminates at Balsam Recreation Area, a national park campground and picnic area at an elevation of 5,300 feet. This spur is particularly nice in mid-June, when it is lined with rhododendrons, and late October, when it yields spectacular fall colors. Two stops are worth mentioning. At 1.4 miles, **Mile High Overlook (37)** gives a 180-degree view toward the Smokies crest, and is one of the finest sun-

*View of the Great Smoky Mountains from Ballhoot Scar Overlook, Blue Ridge Parkway*

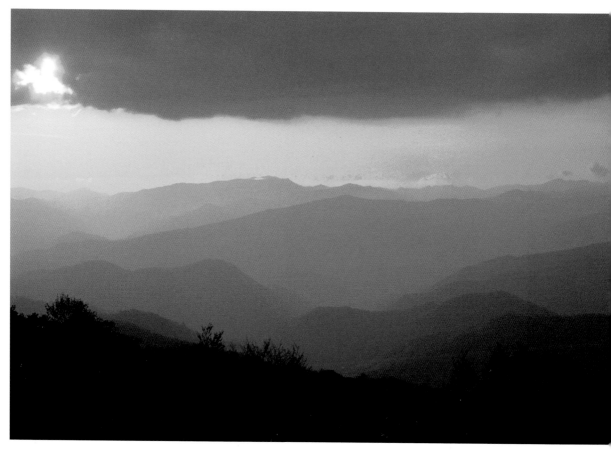

*Sunset view of the Smokies from Mile High Overlook*

set locations in the park. At the end of the road is **Balsam Recreation Area (38)**, the park's highest, coolest, smallest, and most unusual picnic ground. The first tables occupy what mountain folk call a "balsam grove"—a stand of tall spruce trees, spread wide apart with nearly no undergrowth. A short distance along the ridge is a grassy glade under huge old oaks, where you'll find tables made of a single slab of quartzite reminiscent of a druidic altar, very nice for offering picnic sacrifices to the Ant God. (If you want to do a setup of a happy family on a picnic, nothing says "National Park" like a megalithic slab table.) A short distance below the picnic area is one of the park's best

overlooks, Heintooga Overlook, with a view that encompasses the entire Smoky Mountain ridgeline from Clingmans Dome to the Great Balsams. Every point you see is a mile high or more, and nearly every peak reaches 6,000 feet. The sunsets are great.

You will note that a one-lane, one-way dirt track leads north from the end of the pavement: This is Round Bottom Road, and it can be traveled by any normal motor vehicle. It is, however, more than 16 miles long and there is no turning back once you start; some flat-landers find it intimidating. It's interesting and fun, but offers no exceptional photography to speak of.

*The Newfound Gap Road in North Carolina*

# VII. Newfound Gap Road: North Carolina

**General Description:** The Newfound Gap Road runs northward from Cherokee, North Carolina, to Newfound Gap on the crest of the Smokies, then down to Gatlinburg, Tennessee. The North Carolina half predates the Tennessee half by a good 60 years, having been around in one form or another since the Civil War. Mountain writer Horace Kephart has a vivid description of following the road in the early twentieth century to the Smokies crest, where it ended abruptly, with hardly a footpath on the Tennessee side. The modern highway is sleek and wide, sweeping up the Oconaluftee River valley in wide curves until it hits the mountain wall and switchbacks upward. The views from the top are stunning, and get better as you explore the 7.2-mile Clingmans Dome

**Noted for:** Wide views, beautiful stream, working log farmstead, working water mill, and wildlife.

**Watch for:** Very bad traffic at the peak of the tourist season, in the summer and in October. Bears will stop traffic; treat them as dangerous and keep your distance. There are no gas stations between Cherokee and Gatlinburg.

**Facilities:** Picnicking at Collins Creek, 6.6 miles from the park border. National park camping at Smokemont, 4.8 miles. Visitor center at Oconaluftee, 1.7 miles. Restrooms at Oconaluftee, Collins Creek, Newfound Gap, and Clingmans Dome.

**Sleeps and Eats:** In Cherokee.

*View of valley fog from Thomas Divide*

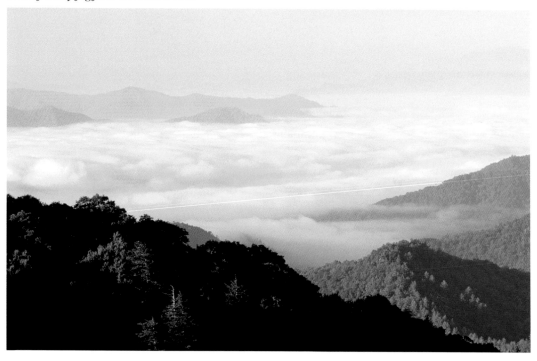

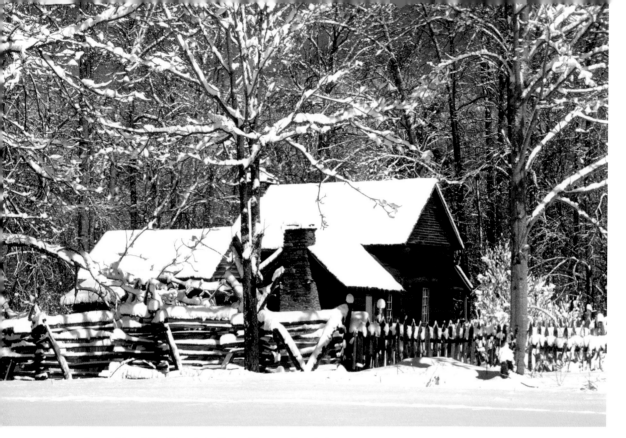

*Log cabin at the Mountain Farm Museum in winter*

Spur Road along the crest to the left. At the start of the road, just up from Cherokee, you'll find two of the national park's finest historic exhibits, a working farm and a working water mill. This section covers the North Carolina half of the Newfound Gap Road, excluding Newfound Gap (19).

**Directions:** Take US 441 through Cherokee; it becomes the Newfound Gap Road at the national park's border.

### Mountain Farm Museum (39)

Located 1.35 miles from the national park border, the Mountain Farm Museum is one of the most complete, and one of the most handsome, exhibits on mountain farm life anywhere in the southern Appalachians. Unlike other restored farm sites elsewhere in the park, the Mountain Farm Museum doesn't just leave you with historic plaques by empty buildings. It portrays a full-sized operating farm—flowers along the porch, furniture in the house, corn in the field, chickens in the coop, a horse in the barn, and costumed docents to help you understand it all. The farmstead consists of log structures, all built around 1900, moved in from remote areas of the park. The farmhouse is surrounded by hand-split pickets and planted with beds of native flowers. The barn anchors the other end of the site; original to this location, its clapboarded log hayloft is cantilevered over log cribs, an attractive style unique to the Smokies. Inside are examples of period farm equipment, a horse, several stray chickens from the nearby coop, and a cat. Between the two main structures lies a working late-nineteenth-century

farm, with period crops tended by volunteers in period dress using period methods. Adjacent to the Farm Museum is the modest Oconaluftee Visitor Center, a classic 1930s stone building housing an information desk, bookshop, and interpretive exhibits.

## Mingus Mill (40)

Mingus Mill is a late-nineteenth-century grist mill restored to operation, located on the Newfound Gap Road a short distance beyond the Mountain Farm Museum (2 miles from the park border, on the left). In its time it was a modern facility, with two grist stones powered by an efficient store-bought turbine instead of the old-fashioned hand-carpentered overshot wheel. You can scramble under this large clap-board building to photograph the turbine in operation, then go inside to watch the miller operate the great grist stones. However, the mill's most impressive part is its elevated race, standing 20 feet off the ground as it passes into the building to fall into the turbine. There's a short, pleasant walk that follows the mill race to the mill's small log dam on Mingus Creek.

## Up the Newfound Gap Road (41–43)

For seven miles beyond Mingus Mill, the Newfound Gap Road follows the Oconaluftee River in broad sweeps. For the first few miles, the road passes into, then out of, riverside meadows; here, at dawn, the deer may outnumber the tourists. You'll pass the park's large Smokemont campground at 4.8 miles from the

*Mill race at Mingus Mill*

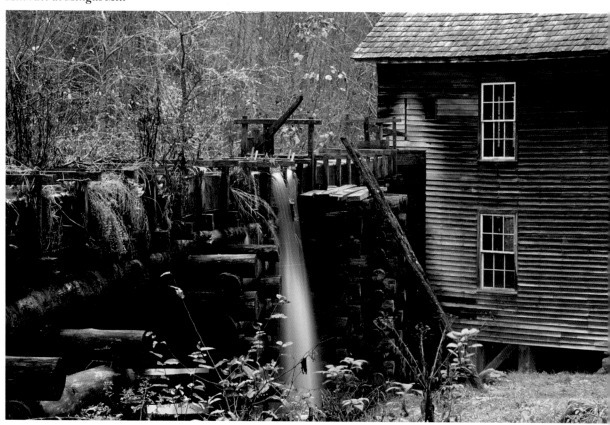

border. From here the Oconaluftee valley becomes increasingly steep-sided and narrow, and the river itself becomes a stream: the rapids of the **Oconoluftee River (41)**, with no waterfalls but many beautiful, unnamed cascades. There are several good places to photograph this, a good cloudy-day subject, starting with a large pullout at 6.2 miles where the road be-

*View of the Great Smoky Mountains from Thomas Divide, Blue Ridge Parkway*

comes embanked over the stream. After 9 miles the road begins to climb steeply, then switchbacks up the wall-like side of the Smokies to gain **Thomas Divide (42)**, a side ridge, at 4,500 feet. From here you will find a series of some of the finest views in the park, starting at the sharp curve just before the crest (13.4 miles) and climaxing with a 180-degree panorama from the top of an embankment, reached by a catwalk (14.8 miles). This is the best place to photograph valley fog, which, if you are both early and lucky, will be blanketing the valleys, with the highest peaks sticking up like islands. Finally, for a sunrise shot, set up at **Oconaluftee Valley Overlook (43)**, at 16.5 miles; the 90-degree view, hemmed in by high ridges despite its 4,900-foot elevation, looks straight down a valley that points directly southeast. You'll reach the Clingmans Dome Spur Road (44) at 17.1 miles, Newfound Gap (19) at 17.2 miles, and Gatlinburg at 31.0 miles.

### Clingmans Dome (44–45)

Running for 7.2 miles along the crest of the Smokies, **Clingmans Dome Road (44)** starts at Newfound Gap (19) and ends at the tallest peak in the park, Clingmans Dome. More than any other park road, this drive has the look and feel of a 1930s New Deal work project, narrow and twisting, shaded by the spruce forest crowding its edge, with trimmed rock walls on the downhill side. Its cuts are too modest to provide the wide views of a more modern highway, and its shoulders are frequently too narrow to pull off and park on. The first view (0.4 miles from the beginning) is one of the best, a 5,200-foot-high bird's-eye straight down a V-shaped valley, with the Newfound Gap Road curving away below. If you've hit clouds or fog, a nature trail at 2.5 miles takes you into the spruces for good forest shots. Then, at 5.3 miles, Webb Overlook gives another fine view eastward. The best views, however, come at the

large parking lot at the road's end, officially named Forney Ridge Overlook, with wonderful panoramic views east, south, and west over endless mountain ranges—your best place to catch sunrise over valley fog. At the far end of the lot is a 1.6 mile (round trip) paved trail to the 6,643 foot summit of **Clingman's Dome (45)**, a conical peak on the Smokies crest, covered in subarctic spruce forests. Its views are courtesy of a large modernist lookout tower, a round concrete platform atop a long spiral walkway. Views are in all directions—along the forest-clad crest, down the Smoky Mountain Front into Tennessee, and back along the wavelike mountains of the North Carolina Blue Ridge region. On warm summer days, a dirty haze may obscure the lower elevations and ruin your view pics; in such weather, shoot at sunrise or sunset (always spectacular).

## Balds of the Smokies Crest (46–47)

Up until the Civil War mountain farmers practiced transhumance on a large scale, pasturing over 100,000 head of cattle along the Smokies crest. Needless to say, those cattle weren't grazing on spruce needles and oak leaves; the crest was covered by vast grassy meadows called "balds." Perhaps created by the cold climate of the Ice Age, these balds were most likely originally the gazing grounds of elk and bison. The Cherokee maintained them with fire to encourage game, until European settlers moved in. When cattle grazing stopped in the massive economic collapse known as Reconstruction, the forests quickly grew back—possibly for the first time in thousands of years. With two small exceptions, the National Park Service has no policy to restore past balds or protect current ones from afforestation. Today only a few grassy balds remain, and two of the best are within a day hike of Clingmans Dome. **Andrews Bald (46)**, 1.6 miles below the Clingmans Dome parking lot (600 feet of climb on

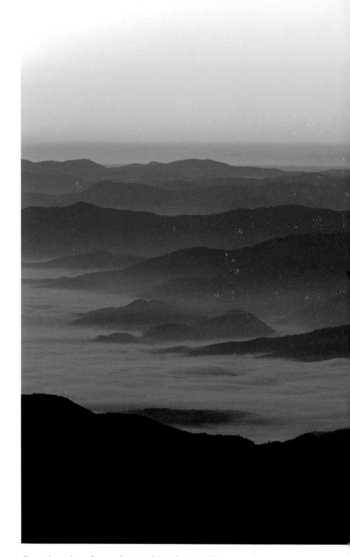

*Sunrise view from the parking lot at Clingman's Dome Overlook*

the return) is one of the two maintained by the park rangers, hand-cleared of woody invaders every few years; it gives stunning views, particularly in mid-June when the rhododendrons are covered in blooms. Then, west of Clingmans Dome, a series of grassy balds continue to survive along the Smokies crest; to reach these in a day hike, follow the Appalachian Trail toward **Silers Bald (47)**.

*The Palmer House*

# VIII. Cataloochee Cove

**General Description:** Located in the park's far southeastern corner, Cataloochee Cove features a wide, flat-bottomed valley, carpeted in meadows and studded with historic farm structuresmuch like Cades Cove (covered in part III). Unlike Cades Cove, Cataloochee Cove can only be reached via an extraordinarily bad (even by Smoky Mountain standards) gravel road—narrow, steep, and twisting, frequently with no room for two cars to pass, with gravel that acts like ball bearings under your tires, and with oncoming traffic that includes people hauling campers and fifth-wheels. As a photographic destination, it is beautiful and

**Noted for:** Pastoral scenery, historic sites, wildlife (including elk), wide views.
**Watch for:** Extremely bad access roads. Gasoline is not available.
**Facilities:** National park camping. Restrooms and a couple of picnic tables at Palmer House (48). Information at the ranger station by Will Messer Barn (49).
**Sleeps and Eats:** In Maggie Valley. From I-40's exit 20, go south on US 276 for 5.6 miles, then turn right onto US 19, along which this tourist settlement stretches for the next six miles.

has many choices of subject, but it lacks Cades Cove's visual drama. It's a good place to photograph wildlife, and almost the only place to find the recently reintroduced elk; the excellent campground makes it a bit easier to be there at dawn or dusk, without having to negotiate the entry road in the dark.

**Directions:** Cataloochee Cove is reached by a gravel road that runs along and through the national park's eastern edge. Old-timers remember this as NC 284; North Carolina "solved" the problem of a dangerous, dirt-surfaced state highway by simply dropping its number. From the south, take I-40 to US 276 (exit 20); then take the first hard right after the exit ramp onto Cove Creek Road, which becomes a steep, narrow, twisting gravel road before crossing a mountain and intersecting with the paved park road through Cataloochee Cove at 7.2 miles. Turn left here. From the north, exit I-40 at Waterville (exit 451), proceed as to Big Creek (27), and turn left onto gravel Mount Sterling Road; your first right, in 11.6 miles, takes you into Cataloochee Cove via a gravel road, while your second right, at 13.6 miles, uses the cove's main paved road. The northern approach, although longer, is better in quality than the southern approach, with lower gradients and gentler curves.

## Big Cataloochee (48–52)

Cataloochee Cove is sometimes known as "Big Cataloochee" to distinguish it from a nearby settlement known as Little Cataloochee (52). It's a lovely place, little visited, with meadows and farmsteads along Palmer Creek. It has three roads: the entrance road, a bad dirt road that here winds through forests above the cove's eastern edge, and two roads that extend westward from this one. The first of the two, a paved, modern highway to nowhere built in the 1960s as part of an abortive attempt to turn Big Cataloochee into a major recreation area, runs

along the hills south of the cove to intersect Palmer Creek and the traditional road near the campground. The traditional road, 2 miles further, follows Palmer Creek to reach the **Palmer House (48)** (1.2 miles), a 1924 farmhouse built around an 1860 log cabin, very handsome and photogenic, demonstrating how such a building would be modernized over the decades. At 1.2 miles it intersects the main road and becomes paved; then, at 2.5 miles,

*View from an overlook on Cataloochee Cove Road*

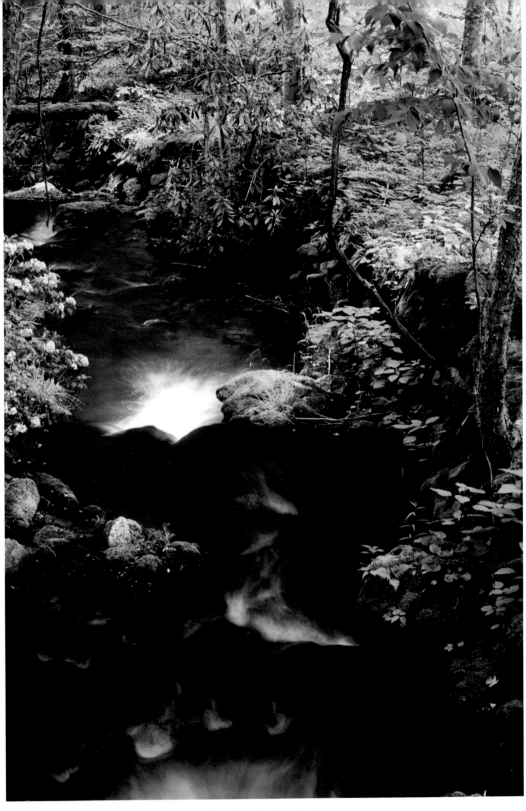

*An old stone wall runs along the bank of Little Cataloochee Creek.*

*Inside Little Cataloochee Church*

the **Will Messer Barn (49)** stands near the ranger station in a meadow. The first of two large meadows starts at 2.7 miles; if you see no wildlife, use binoculars to search the shadows in the forest fringe. At the meadow's end (3.4 miles) is attractive little **Palmer Chapel (50)** on the left, still in use (by the campground and for weddings), and then, on the right, the one-room Beech Grove School, fully furnished.

Now the road turns to gravel again and another large meadow starts. You'll reach the **Caldwell House and Barn (51)**, unusual within the park for being completely modern, frame-built built in 1906 with Victorian features. Both the meadow and the road end at 4.4 miles; but you can walk along the closed road bed for another 0.9 miles to the last structure, the **Woody House (52)**, an early log cabin substantially expanded in 1910.

## Little Cataloochee (53–55)

While Big Cataloochee is the central attraction, its former sibling Little Cataloochee, is not without interest. Access is by a trail that follows the old settlement road, an uphill walk of 2.6 miles with 400 feet of climb. You'll reach the modest, one-room **Hannah Cabin (53)** at 1.1 miles (down a side trail to the right); then, at 1.3 miles, the trail crosses pretty Little Cataloochee Creek, with some attractive settlement remains. At 1.9 miles is **Little Cataloochee Church (54)**, well kept and furnished, still used once a year for a reunion of Little Cataloochee's biggest family. The trail reaches the **Cook Place (55)**, the scant ruins of a commercial apple farm from the 1890s, at 2.6 miles, then continues to Big Cataloochee and comes out at the Beech Grove School after another 3 miles, 500 feet of climb, and 1,000 feet of drop.

*View east from the Foothills Parkway over Happy Valley, toward the national park*

# The Northwest Quadrant

The northwestern quadrant of the national park centers on the tourist settlement of Townsend, once a timber railhead and now a pleasant, laid-back string of lodges and restaurants, nearly all of them independent. Townsend got its start as the place where watersheds—and therefore timber railroads—funneled to a single point. Today, national park roads converge here, with Little River Road following its stream uphill to the east and Cades Cove Road heading west. Cades Cove is one of the premiere beauty spots in the eastern United States, a flat, square valley in broad meadows with log cabins and barns, surrounded on all sides by the massive peaks of the Smokies. The former timber lands offer a range of photographic opportunities as well: forests, rivers, and the remains of the logging operations. On the far western edge of the park, best reached from Townsend, the western segment of the Foothills Parkway follows a low, linear mountain crest for 17 miles, with good views.

# IX. Townsend

*Free live performances are a regular feature in Townsend.*

**Noted for:** A good headquarters for visiting the northwestern quadrant, and a quiet alternative to Gatlinburg.
**Watch for:** No special problems here.
**Facilities:** Just about everything.
**Sleeps and Eats:** A wide choice of locally owned places, including excellent cabins. Little by the way of national chains.

**General Description:** Townsend is a pleasant settlement, low-key and mildly attractive. It sits in a broad, flat valley along the Little River, which here is much gentler than in the park. You'll find Townsend to be more a place to stay and eat than a place to photograph. It has a couple of nice bed-and-breakfasts, a large log resort hotel, and a good selection of motels. It's best known, however, for its cabins, with a number of custom-built log cabin villages to choose from as well as the usual second-home rentals.

**Directions:** Townsend sits on the northwestern edge of the national park, where US 321, running between Maryville and Gatlinburg, dips closest to the park. From Gatlinburg, either take US 321 westward for 24 miles, or travel through the park on the scenic but curvy Little River Road for 22 miles.

## Sights to Photograph around Townsend (56–58)

Townsend is a place to stay and eat, rather than a destination in itself. It's not a bad-looking place by any means—quite the contrary. It's just dwarfed by the wonders within the national park, just three miles from the town center. Townsend sits on the **Little River (56)**, suddenly subdued as it runs out of the park, a wide Class II water; look for photos mainly

downstream from town, along the old road that runs along its right bank. At the center of town is the **Little River Railroad and Lumber Company Museum (57)**, dedicated to the logging industry that created the town; it has a fine depot and a restored Shay railroad engine, designed to pull up steep mountain grades and around sharp curves. **Dry Valley (58)**, left down Dry Valley Road past the western end of town, offers the best rural scenery, and a suggestion of what Cades Cove would have looked like today had it not been incorporated into the national park.

### Foothills Parkway West (59)

The western of the two finished sections of the Foothills Parkway (26) runs for 17 miles along the crest of long, skinny Chilhowee Mountain.

*The Little River Railroad and Lumber Company Museum*

*The Little River at Walland, west of Townsend*

This mountain is of a type familiar in Virginia and Pennsylvania, but rare in Tennessee: a single, gapless ridge running in a straight line for a long distance, not particularly high but with very steep sides, and with a rocky, barren top. It offers great views eastward over the Smokies, and wider but less photogenic views (except at sunset) westward over the flat lands of Tennessee's Great Valley. The best photography is at the road's one recreation area, Look Rock, right at the middle; here you will find a lookout tower on top of an outcrop.

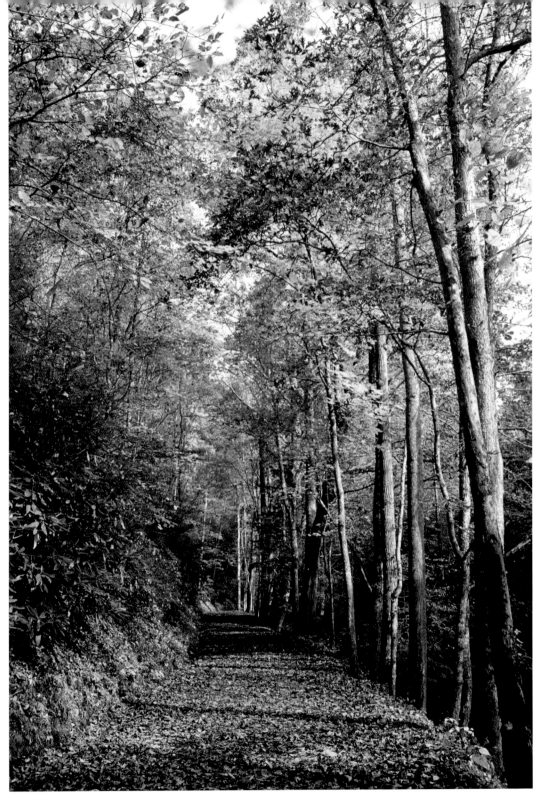

*An old timber railroad grade now carries an easy footpath.*

# X. The Little River Gorge

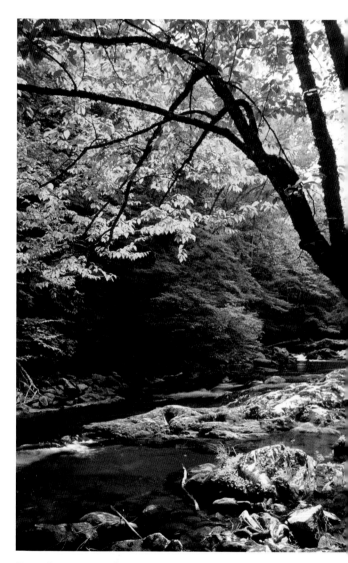

*Lynn Camp Prong flows past Tremont Logging
Camp.*

**General Description:** In one of those geologi-
cal oddities that adds charm to the Blue Ridge
and Smoky Mountain regions, the Little River
cuts crosswise across the side ridges of the
Smokies for nearly 15 miles of its east–west
run, before suddenly turning north to leave the
mountains at Townsend. This, however, is not
the end of this peculiar little gorge, for one of
its tributaries, east-flowing Laurel Creek, con-
tinues to carve across side ridges for another 6
miles. In the early twentieth century the Little
River Lumber Company used these 21 miles
of gorge to reach the virgin forests of the north-
western Smokies, clearcutting one watershed
after another until, in 1939, the entire slope
had been stripped bare. Then they sold it to
the National Park Service at a profit.

The massive little Shay railroad engine (57),
its external gears attached directly to its wheels,
allowed the company to do this, pulling heavy
strings of cars along 6-percent grades and
around sharp curves; at one point (alas, long
gone) it even pulled logging trains across a
swaying, sagging suspension bridge. You can
see the Shay's grade and curve requirements in
every twist and turn of theroads in this section
and along the wide, easy trails that push up the

streams, past the ruined remnants of the lumber camps and into the second-growth forests that now blanket all slopes.

**Directions:** From Townsend head south on TN 73 until it enters the national park and becomes the Little River Road, reaching a Y intersection (called, unsurprisingly, "The Y") in 0.7 miles. Little River Road heads left, east, to Elkmont (12.5 miles) and Sugarlands (13) (16.4 miles).

## Tremont Logging Camp (60)

While all logging camps are ephemeral, Tremont served as an important logistics depot, so it was larger, lasted longer, and left more remains than most of the others. Even better, these remains are easy to find and photograph thanks to a National Park Service interpretive "nature" trail, whose booklet should be available at the trailhead. A big photographic plus is the modern steel truss bridge that crosses the creek on old railroad masonry.

Middle Prong Trail follows the railroad grade uphill from the camp, leading to a fine (and as far as I know unnamed) waterfall in 0.3 miles, then another one at 0.5 miles. There are logging remnants along the trail, as well as the scant remains of a Civilian Conservation Corp camp that restored stripped slopes while clearcutting was still taking place nearby. Rail fans will want to continue to the 3.5-mile point, where there's a series of four rare railroad switchbacks; here the train climbed a particularly steep slope by going forward, then backward up a series of inclines. To find Tremont, take Cades Cove Road 0.2 miles to Tremont Road, then turn left and follow it (becoming gravel after 2 miles) to its end, a 5-mile trip.

## The Little River Gorge (61–63)

East of Cades Cove, 21 miles of park roads sit atop the railroad beds of the Little River Lumber Company; to follow these roads, start at the Cades Cove picnic area and take the Cades Cove Road away from the cove, toward Townsend. The first 1.7 miles are modern; then the highway takes to the old logging rail bed, acquiring its even gradients and sharp curves. Frequently the road becomes a narrow shelf cut into the mountain slope, with the stream racing along on one side and a vertical

*The Little River*

rock face on the other. You'll pass a tunnel and a waterfall, then the side road to Tremont Logging Camp (60), before you reach the fork to Townsend (0.7 miles on the left) at **The Y (61)**, a popular swimming hole with a sandy beach. From there the old rail bed goes right, following the Little River Road upstream. Now the road/rail bed winds sharply while hugging this full-volume, cascading river. Views over the river are continuous, with parking spaces for fishing doubling as places to pull over and take a picture. At **The Sinks (62)** (parking at right, over a bridge) there's a clifftop view of a stone bridge framed by two large waterfalls. A few miles down the road you will reach the picnic area at **Metcalf Bottoms (63)**, another popular swimming place, and a good place for stream pics with and without waders. Here a side road leads to the historic community of Little Greenbrier (64–65). The Little River Gorge ends at the side road to Elkmont National Historic District (66), where the old rail bed turns right and a modern road takes you on to Sugarlands (13).

## Little Greenbrier (64–65)

Little Greenbrier is little visited, yet oddly compelling and highly photogenic. To find it, follow Wear Gap Road from the Metcalf Bottoms Picnic Area (63) for 0.5 miles to a right turn onto a one-lane gravel road with oncoming traffic and no pullouts; continue another 0.5 miles to the end. (To avoid the gravel road, park at Metcalf Bottoms and follow the Little Greenbrier Trail to the schoolhouse, 0.6 miles with 150 feet of climb.)

You'll be parked by a log-built, one-room **Little Greenbrier schoolhouse (64)** that started life as a church—hence the presence of a pioneer cemetery on the hill above. The Greenbrier schoolhouse is still in use, mainly as the site of history field trips for local schoolchildren. With a bit of luck you'll find it open

*Schoolteacher Elsie Burrell awaits a class at Little Greenbrier School.*

and class in session, with a full set of early-twentieth-century texts and teaching aids. One of the Greenbrier cabins still survives, a remote 1.2-mile walk (each way) from the school, along the gated jeep track across from the cemetery. A lovely and nearly level walk, the track follows Little Brier Creek upstream to the **Walker Sisters Cabin (65)**. Set in a clearing with a springhouse and barn, this fine cabin was the

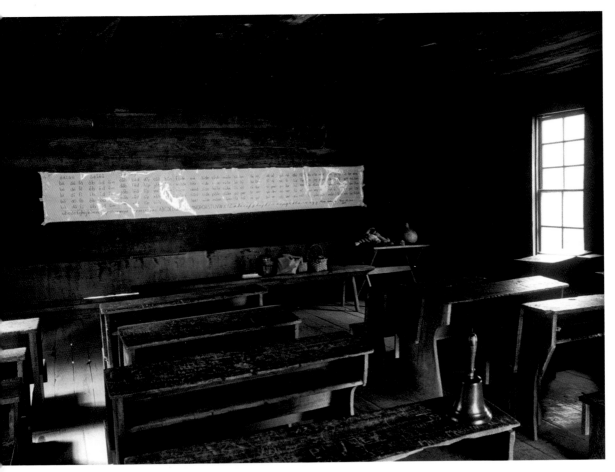

*One-room schoolhouse at Little Greenbrier*

home of the Walker sisters, who refused to move out of the park until the 1960s. No other historic site in the park gives quite this feeling of remoteness, quiet, and simplicity.

## Elkmont National Historic District (66)

Founded in 1908 as a logging camp, Elkmont gained unexpected popularity as a tourist destination and second home community for Knoxville's urban elite until it was condemned by the National Park Service in the 1930s. For various reasons, many of the vacation cabins remained in control of their original families until 1992, when the park service finally gained full possession. By this time Elkmont had been declared a National Historic District, with 69 structures on the National Register of Historic Places. You might think this means that Elkmont is an exceptional place with wonderful architecture, but it's not; it's just a typical 1920s-era cabin resort that's never been updated (even with electricity). After 18 years of legal battles over its status, the National Park Service (which wanted to tear it down) recently agreed to preserve a 19-building core as a historic exhibit. The rest of the site will be cleared and restored to riverine cove hardwoods, rather than simply abandoned; but as of press time,

none of this has been funded. What you see now is a collection of decrepit cabins around a tired old clubhouse, everything looking overgrown and unloved. It's a good place for mood shots and details, and the handsome local stream is easily explored along a railbed trail.

## Laurel Falls (67)

Perhaps the most popular trail in the national park, paved Laurel Falls Trail climbs 300 feet in 1.2 miles, starting on Little River Road opposite the Elkmont Spur Road (66). You'll find it a dramatic walk, with the trail frequently just a ledge blasted out of sheer rock. Laurel Falls drops 75 feet in two jumps, with the trail crossing the ledge halfway down; a steep and dangerous informal track leads to the bottom. The trail continues uphill for some distance, exploring a virgin forest in which a cove hardwood environment slowly transforms into dry ridgetops. Parking can be very difficult, so an early start is a good idea.

*Historic second home in Elkmont National Historic District*

*Hyatt Lane, Cades Cove*

# XI. Cades Cove

**General Description:** Cades Cove is a true box valley, a nearly flat rectangle 1 mile wide by 3.2 miles long, surrounded on every side by tall mountains. It formed as a "limestone window," a feature in which a deep, fairly level layer of limestone is exposed by erosion and then dissolved away, leaving flat lands and rich, well-drained soils. There are several such limestone windows in the area, including Townsend (56) and Dry Valley (58), but Cades Cove is by far the largest and most dramatic.

The National Park Service has done all it can to increase the drama. When they took it over in the 1930s, Cades Cove was heavily set-

*Henry Whitehead Cabin, Cades Cove*

**Noted for:** One of the most beautiful spots in the East, with an amazing variety of photographic opportunities, including wide mountain views and pioneer structures.

**Watch for:** The cove is exceedingly popular and the traffic will frequently gridlock during the peak seasons of high summer and mid-October; this gridlock can extend as far as Tremont, as cars queue up for their turn in the cove. Because many cars stop on the one-lane road, expect the 10.3-mile loop to take from one to three hours. The loop road is best experienced on Wednesday and Saturday mornings before 10:30 am, when it is closed to motor vehicles but open to bicycles. If you drive into bad gridlock, consider parking at the large lot at the start of the loop and then walking.

**Facilities:** The Cades Cove Recreation Area, at the start of the loop road, has a picnic area, camping area, camp store, bicycle rentals, ranger station, and restrooms. Cable Mill, at 5.5 miles, has the only restrooms on the loop road; do not forget that slow-moving traffic could put this up to two hours away.

**Sleeps and Eats:** In Townsend.

tled and completely covered with small farms. It was already a famed beauty spot, with stunning views over prosperous, well-kept mountain farmlands; indeed, the farmers made a nice side business out of renting rooms to tourists. The park service decided to preserve this particular blend of human and natural landscape by turning the cove into a museum of pioneer history. They cleared out most of the buildings and consolidated the small farm tracts into giant hayfields, then preserved 16 structures as typical of pioneer settlements. They then

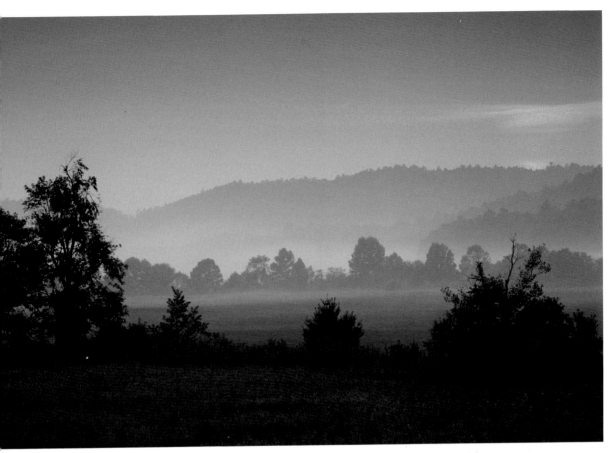

*Dusk view with summer haze, from Cades Cove Loop Road*

replaced most of the old roads with a one-way, one-lane loop that runs around the perimeter, leading from one historic site to another. In the 1950s the park service made its final change, replacing the hayfields' native grasses with exotic fescues. Then the rage among agricultural agents, fescues never grow tall, always stay green (even in the winter), and spread aggressively. While the fescues have pretty much destroyed the native meadow ecosystems by displacing most of the native plant species, they have improved the photography, as those native grasses used to reach six feet in height and turned brown in the fall. Today you'll see wide, verdant sweeps of lawn-style grasses in whatever season you visit. In winter, hundreds of deer form large herds on the green pastures, an amazing sight.

**Directions:** From Townsend, take TN 73 to The Y (61), then go right on Cades Cove Road to reach the Cades Cove Loop in another 7.5 miles. Here a left turn takes you a short distance to the picnic area, ranger station (information), and camp store, where you can rent bicycles. The looped road tour starts straight ahead.

## The Cades Cove Loop (68–79)

All of Cades Cove's photos sites are laid out, one by one, along the 10.3-mile loop road.

Your experience will be one of alternating fields and forests with many changing views over the farmlands to the mountains; the best views are in the first 5.5 miles. Historic sites will appear irregularly along the drive, and all but a couple qualify as exceptional photo sites in themselves. Side roads, listed separately below (80–82), allow you to vary this experience.

The loop road begins at a **horse meadow (68)** where the cove's stable concessionaire pastures its horses; in the morning, grazing horses provide foreground for the wide view over the fields toward the Great Smoky Mountains. From there, the road wanders through forests and meadows for 1.2 miles, to reach (on the right) the parking lot and path for the **John Oliver Cabin (69)**, the cove's oldest and most photogenic log cabin, beautifully framed by split rail fences. At 2.4 miles you'll reach a short, gravel side lane to the **Primitive Baptist Church (70)**, during the Civil War a hotbed of Unionism and a stop on the Underground Railway. At 2.7 miles you'll reach the loveliest of the three surviving cove churches, the white clapboard **Methodist Church (71)**. You'll find wide views from the wildflower meadows above the church. Just after Hyatt Lane (80) comes the **Missionary Baptist Church (72)** at 3.2 miles, at the intersection with Rich Mountain Road (81).

Now that you've reached the western end of the cove, the views reach their finest. You are now on the **Hayfields (73)** stretch of the loop road, a full mile of continuous views in all directions. At 4.6 miles there's parking for the easy, 0.6-mile walk to the **Elijah Oliver Cabin (74)**, a full-size farmstead set in remote meadows, the cove's least crowded but second most photogenic site. Toward the end of the Hayfields, a split rail fence on the right frames views over wildflower meadows toward a large farmstead—the **Cable Mill Area (75)** (entrance at 5.6 miles), for many the high point of the loop with

a visitor center, working water mill, restored farmhouse, cantilevered barn, collection of pioneer farm tools, and craft demonstrations.

From Cable Mill, the loop road turns sharply left as the paved two-way Forge Creek Road goes 0.7 miles to the **Henry Whitehead Cabin (76)**, with Parsons Branch Road (82)

*Gregg-Cable House in Cable Mill Area, Cades Cove*

another half mile ahead. Back at the loop, you'll reach the **Dan Lawson Place (77)** at 6.7 miles, a log cabin behind split rail fences; Hyatt Lane reenters at this point. At 7.4 miles on the right on sits the elaborate **Tipton Place (78)**; its impressive cantilevered barn, a unique folk feature, is the first building you'll see of this complex. The final cabin on the loop, the modest **Carter Shields Cabin (79)** at 8.6 miles, sits in an open glade rich in spring dogwoods. From here you have 1.5 miles of pleasant, if anticlimactic, scenery before reaching the Cades Cove Recreation Area and two-way traf-

fic; the ranger station is a short distance to your right. The start of the loop and the road out of the Cove is 0.2 miles ahead on your left.

### Hyatt Lane (80)

This two-way gravel side road cuts straight across Cades Cove, leaving the loop road at 3.1 miles and rejoining it at 6.7 miles. A good subject in its own right, tree-lined Hyatt Lane is your best place to admire the view from the middle of the cove, a substantially different perspective from the loop road. Lined with wide meadows that invite wandering, it is full

*Cantilevered barn at the Tipton Place, Cades Cove*

of wildlife, including deer and bear. If traffic has snarled beyond endurance, as sometimes happens on a fine fall weekend, this is your best escape route. At its end you'll get a fine view over meadows to the Lawson Place (77), nestled in the forest.

### Rich Mountain Road (81)

This one-lane, one-way gravel road leads 10.9 miles out of the park to the village of Townsend. If you venture 1.1 miles up this road you will find the single best road view in the entire park: a spectacular 180-degree panorama over the whole cove, with the wall of the Great Smoky Mountains revealed in all its glory and the tiny, white Methodist Church on a hill below. From there you'll have an achingly slow 9.8-mile drive through heavy forest, passing over two gaps with many switchbacks, all the way to Townsend; there is no return to the cove. The road ends in Dry Valley (58), a good place to shoot, revealing what Cades Cove would probably look like today if it hadn't become part of the national park.

### Parsons Branch Road (82)

This is one of the earlier pioneer roads out of the cove, and the only motorable road that preserves the look and feel of a nineteenth-century turnpike—9.3 miles of twisting, steep, one-lane, one-way gravel road. It climbs in and out of small mountainside defiles as it rises; forests near the streams have giant hardwoods and hemlocks, while forests on the dry ridgelines have small pines and oaks. You'll reach the first of many fords at 2.7 miles, consisting of a concrete ramp into, then out of, a small stream. The road peaks at Sams Gap (2,780 feet), then drops into a steep defile so narrow that the road is forced into a dozen fords before it ends at US 129 on the southern edge of the park.

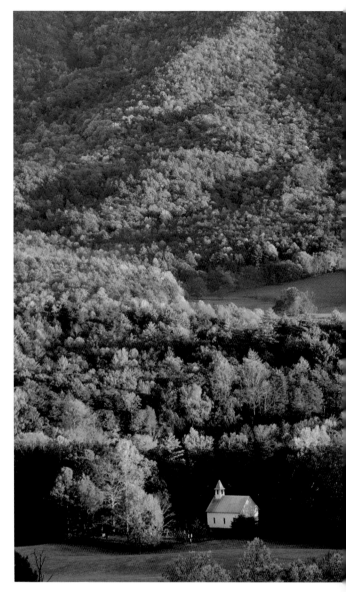

*View over Cades Cove from Rich Mountain Road*

Photographically, its forest scenery is pleasant but unremarkable, and its fords and streams make for good subjects. This makes a fine day trip when you return along the Foothills Parkway (59), just 9.8 miles west.

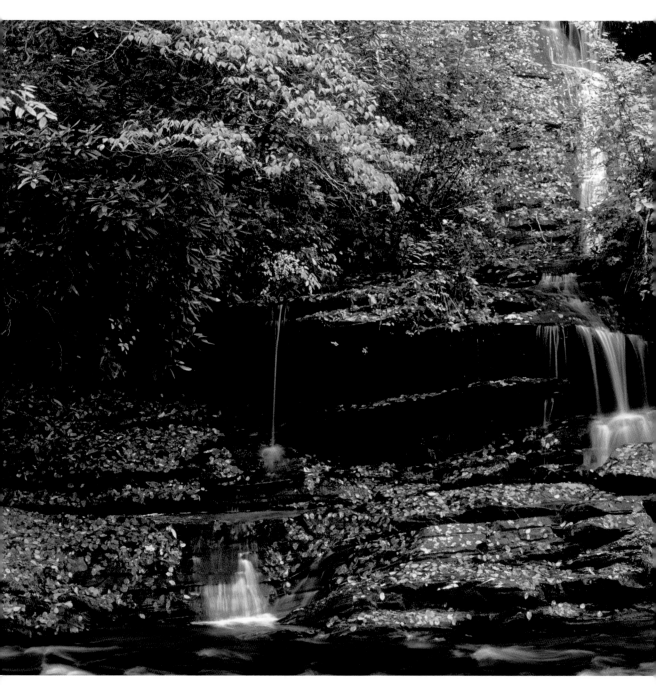

*Tom Branch Falls, in the Deep Creek Area*

# The Southwest Quadrant

The creation of Fontana Dam in 1942 forever changed the character of North Carolina's Southwest Quadrant. Until then, it had resembled Gatlinburg without the tourists: mountain settlements straggling up streams, topped by forests on the steepest slopes. As in other parts of the park, the National Park Service condemned the farms and tore down the buildings, allowing second-growth forest to come up at its own pace. Here, however, wartime needs for electricity led to the creation of Fontana Dam, still the tallest in the East; and the giant impoundment behind the dam submerged all the roads to these valleys, cutting them off to all but hikers. A 1960s attempt to open this area to recreation was aborted over environmental protests, and today the short dead-end parkway is called the "Road to Nowhere" by everyone but the park service, which insists its name is Lakeview Drive. Today, you can explore this area at its two ends: Bryson City, on the eastern end, is by far the more varied and interesting, while he western end, dispersed downstream from Fontana Dam, is so little visited that it has few developed sites—its greatest charm.

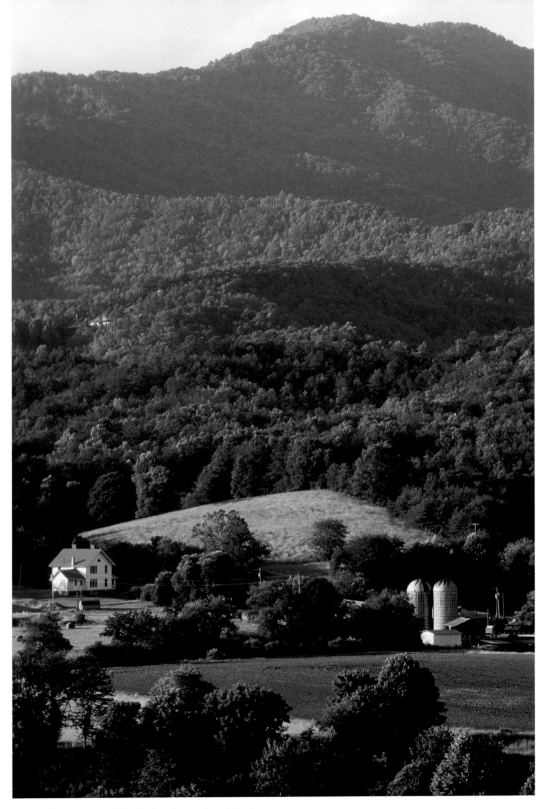

*Bryson City countryside, facing the national park*

# XII. Bryson City

**General Description:** Unlike the other towns in the Smokies, Bryson City is a functioning local service center, a well-kept example of a typical Southern county seat. Tourism is strictly secondary, if not tertiary—which may be why the town's tourist facilities are the best in the Smokies, combining comfort and character. The national park sits a few miles north on good-quality back roads, and features waterfalls, forest walks, and views.

**Directions:** This portion of North Carolina's Southwest Quadrant lies east (upstream) from Fontana Lake, 8 miles west of Cherokee. Go

*A produce stand in Bryson City*

**Noted for:** Unspoiled small town, waterfalls, unusual views over Fontana Lake, forest walks, settlement remains. Deep Creek is the only place in the park where limited off-road bicycling is permitted.

**Watch for:** There are no particular problems in this area.

**Facilities:** Picnicking in the park at Deep Creek, and outside the park on Fontana Lake (86) and by the new county courthouse; national park camping at Deep Creek; restrooms at Deep Creek.

**Sleeps and Eats:** Bryson City has good locally owned restaurants and a wide choice of truly excellent B&Bs.

west on the high-speed multilane US 74 or the two-lane US 19. There are three exits marked "Bryson City"; use the middle one, exit 67.

## Bryson City (83–87)

Bryson City offers the photographer an opportunity unique in the Smokies: a small, old-fashioned country town virtually unspoiled by tourism. Not that tourist facilities are absent; to the contrary, Bryson City's full complement of locally owned restaurants and inns, invariably housed in historic structures, offers a welcome opportunity. The large downtown is lined with brick and wood buildings from the nineteenth and early twentieth centuries, and has a fine variety of shops. The town forms an inverted T, following east–west US 19 for four blocks, then extending north across the Tuckaseegee River for another four blocks to the railroad's passenger depot. The **old county courthouse (83)** marks the intersection, a wonderful Victorian structure with a doughboy statue in front. Against all odds the passenger depot is fully

functional, a terminus on the **Great Smoky Mountains Railroad (84)**, which runs tourist excursions by day and freight trains at night; here you can photograph people boarding historic cars, pulled, if you're lucky, by a steam engine (they use diesel engines as well). For a good view of Bryson City, go to the **Bryson City Cemetery (85)**, on a hill overlooking downtown. Here you'll see not only a fine view of a classic small town, but also the grave of writer Horace Kephart and the stone that inspired Thomas Wolfe's novel *Look Homeward, Angel*. If you have time you might want to drive down Bryson Walk (just north and left from the depot) 2.7 miles to the **head of Fontana Lake (86)**, a good picnic area with good shooting on a sunny morning when the lake level is high.

*Rafts stacked at a Forest Service takeout spot in Nantahala Gorge*

One final site merits a mention. Thirteen miles south of town along US 19 is the **Nantahala Gorge (87)**, the training ground of Olympic whitewater kayaking champions and favored by rafting outfitters—one of the easiest and most rewarding places in the South for shooting those who shoot rapids. Here US 19 parallels the entire river along the gorge bottom, with many places to pull over and photograph the action.

## Deep Creek Waterfalls (88)

This pleasant little recreation area, 3 miles north of town, is best known for its three superbly photogenic waterfalls, almost on top of each other on level paths. To reach the trailhead from Bryson City, turn right on the first street above the passenger depot and follow the brown signs. The first waterfall, the wonderfully named Juney Whank Falls, is a collection of large trickles dashing over rocks a short distance up from the picnic grounds on a side trail. The other two falls are along the main Deep Creek Trail, an old state road from pre-park days and the only footpath in the park open to bicyclists. Tom Branch Falls, one of the park's prettiest, jumps down a 20-foot cliff straight into Deep Creek, 400 yards from the trailhead. A half mile further (with no significant climb), down a right fork, is Indian Creek Falls, a single 30-foot drop full of noisy water, perhaps the classic Smokies waterfall.

## The Road to Nowhere (89)

When Fontana Lake engulfed the state highway through the Smokies to its north, the National Park Service formally agreed to replace it. Twenty years later (in the 1960s) they finally started construction, only to stop after building less than 6 miles, yielding to the objections of environmentalists; the project was formally abandoned in 2010. There it stands to this day, the Road to Nowhere (official name: Lakeview

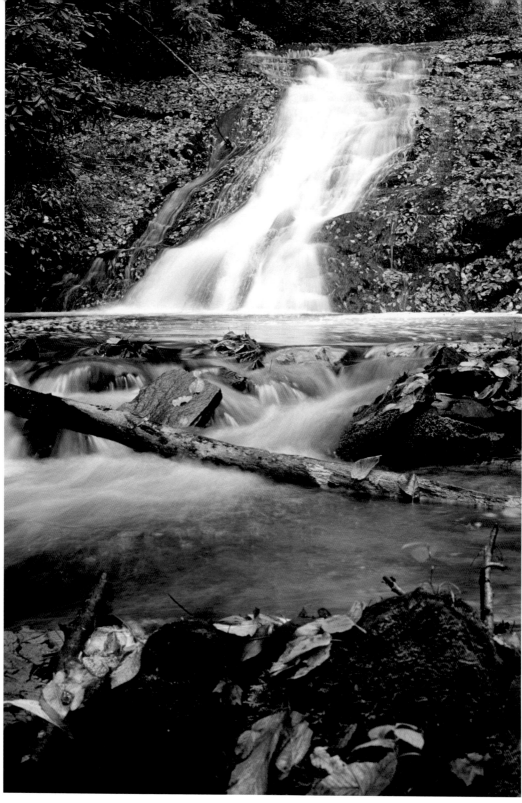

*Indian Falls, in the Deep Creek Area*

Drive). To find it from Bryson City, continue straight on Everett Street past the depot to the park border in 2.7 miles. It's a pleasant drive through young forests, with some excellent wide mountain views southward over the wavelike ridges of the North Carolina mountains. Fontana Lake will be in the middle ground in some of the best views, and can be particularly striking at low water, when it's outlined by a red clay ring.

*Log footbridge on Noland Creek Trail*

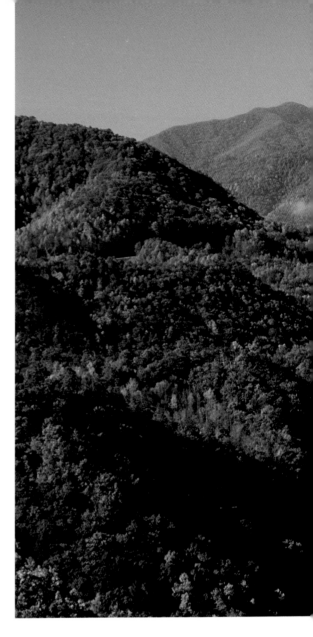

## Noland Creek Trail (90)

This 9.6-mile (round trip), with 700 feet of climb walk follows an old state road through what was once a heavily settled valley and is now attractive second-growth forest; the trailhead is at the last overlook on the Road to Nowhere (89). Noland Creek is not only an un-

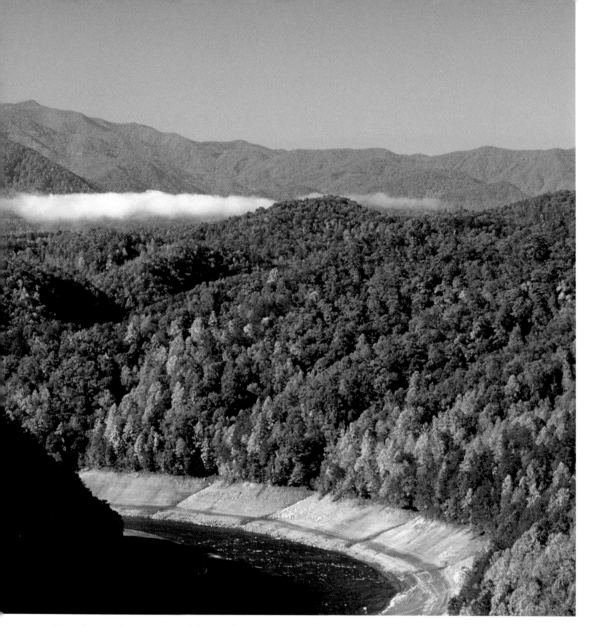

*View from Lakeview Drive (the Road to Nowhere) over Fontana Lake*

usually handsome walk, with fine forests and a lovely stream, but it offers one of the largest and best-defined sets of settlement ruins in the park—the remnants of the National Park Service's condemnation and clearing of this valley in the early 1940s. Look for foundations, stone walls, boxwoods, and roses, as well as the occasional relics such as jars and tools. At 4 miles is the settlement center, and here, where the road crosses the stream, you will find the largest ruin, the foundations of a gristmill. A side trail leads uphill into a virgin forest, while the main trail continues deep into the back country.

*View of Fontana Lake from an overlook on NC 28, east of Fontana Village*

# XIII. The Fontana Area

**Noted for:** Fontana Dam, hydropower lakes, remoteness.

**Watch for:** Gas before you go, as gas stations are few, far between, and have limited hours.

**Facility:** TVA restrooms, picnicking, and camping at Fontana Dam.

**Sleeps and Eats:** Limited options at Fontana Village, a privately owned resort that occupies the dam's original work camp.

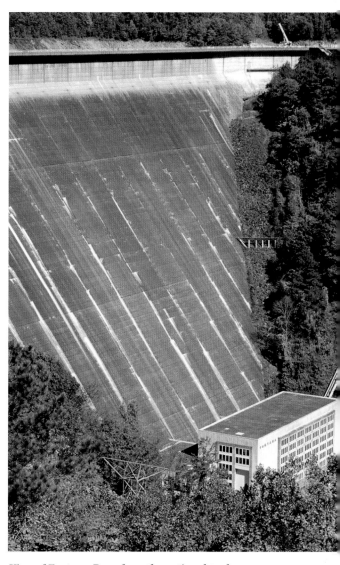

*View of Fontana Dam from the national park*

**General Description:** While Fontana Lake cuts off the bulk of the Southwest Quadrant to casual access, downstream from Fontana Dam the Smokies are once again easily reached. The biggest attraction of this area, however is the dam itself, the tallest in the East. The little-visited Twentymile area anchors the park's far southwestern corner.

**Directions:** From Bryson City take US 74 west for 8.8 miles to a right onto NC 28, which roughly parallels the park's southern border for the next 31 miles. Fontana Dam is down a right fork at the 21.2-mile mark.

## NC 28 (91–93)

This 31-mile drive, paralleling the park's southern edge, starts as an expressway but slowly morphs into a narrow, winding mountain lane. For its first 21 miles Fontana Lake sits between this and the park, with no access other than by boat; the last two miles of this stretch have a couple of really fine **Lake Fontana views (91)** from a slope high above the lake, showing the reservoir and the Smoky Mountains beyond. You'll pass the fork to Fontana Dam (94) at 21.2 miles, then take a left fork to Fontana Village (gas, food, lodging) at 22.4 miles. At 23.9 miles the highway crosses **Lake Cheoah (92)**,

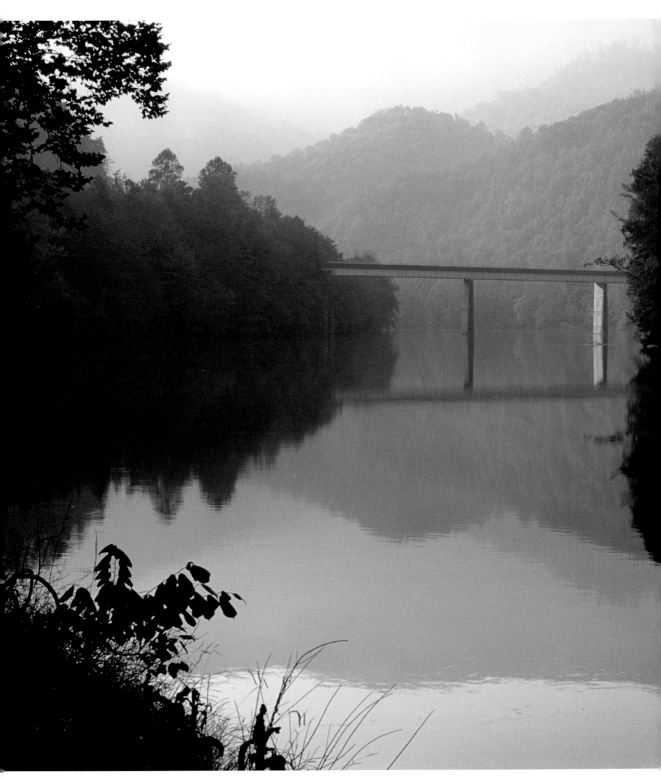

*NC 28 crossing Lake Cheoah*

*Fontana Village Marina on Fontana Lake, just off NC 28*

whose waters back up nearly to Fontana Dam; here a right turn takes you 1 mile to the base of Fontana Dam, which faces south and makes a good subject on a sunny day. The road now closely follows narrow Lake Cheoah; look for a good view back to the highway bridge at the first pull-off, then (at 27.1 miles) a good view across the lake to the Cheoah Powerhouse, an early industrial Gothic structure with giant pipelines running into its rear. The entrance to Twentymile (95) is at 28.8 miles, and NC 28

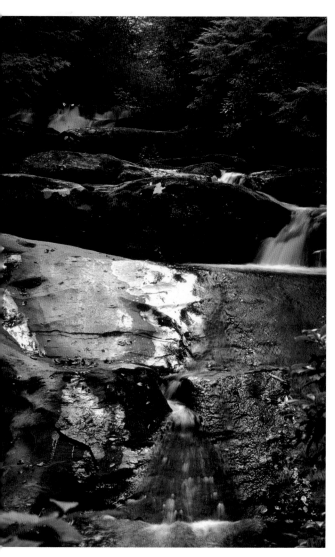

*Twentymile Creek Falls*

ends at US 129 at 31.5 miles. Continue 2 miles left for a great view of **Cheoah Dam (93)**, built in 1911 and the tallest in the East until Fontana was constructed.

### Fontana Dam (94)

Built between 1942 and 1944 as part of the war effort, Fontana is the tallest dam in the East; it's reached from NC 28, 21 miles west of US 74. The approach road leads through a large TVA recreation area with picnicking, camping, and good views over the lake. At the dam you will find a remarkable modernist visitor center built into the structure itself, hanging over the gorge; an elevator goes down from the center to the powerhouse below, which is open for tours. The main road, which continues over the dam, was built to carry a new north shore highway, never completed, whose short eastern section is now the Road to Nowhere (89). The best dam view is on the opposite side, to the left; to the right is a major backcountry trailhead.

### Twentymile (95)

This remote and little-visited site, 28.8 miles west of US 74 via NC 28, serves as the ranger station for the backcountry of the Southwest Quadrant. Logged in the early twentieth century, its old timber road now forms a good hiking trail, leading in 1 mile to an attractive waterfall. Continuing, a 6.5-mile loop trail forms a pleasant forest walk with 1,300 feet of climb, good for a cloudy day.